First Impressions

This book belongs to

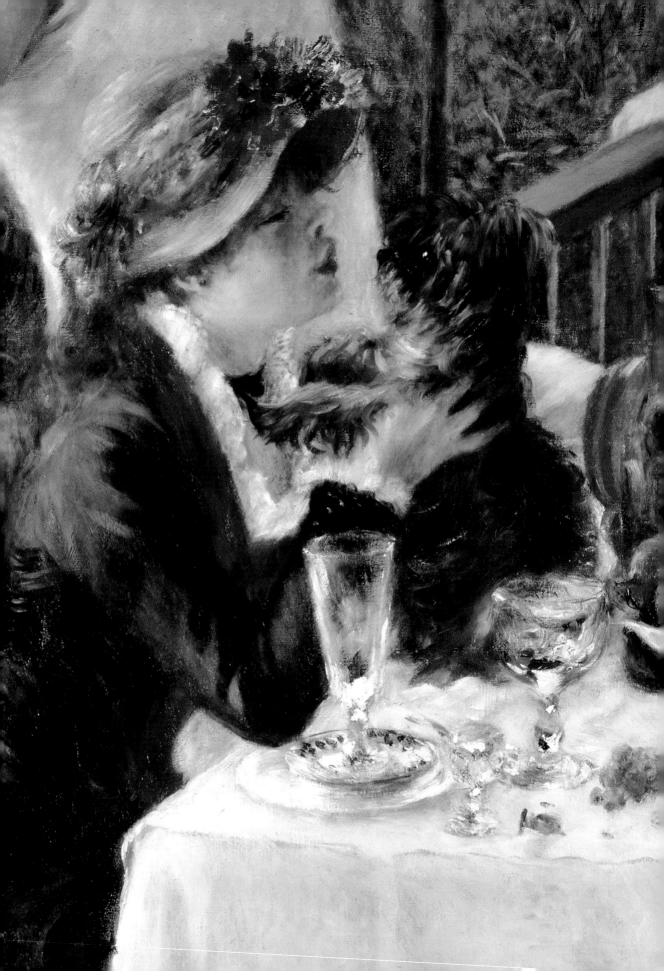

FIRST IMPRESSIONS

Pierre-Auguste Renoir

Susan Rayfield

HARRY N. ABRAMS, INC., PUBLISHERS

For my good friend Veronica Foster

10/99

**92
REN**

Series Editor: Robert Morton
Editor: Nola Butler
Designer: Darilyn Lowe Carnes
Photo Editor: Lauren Boucher

Library of Congress Cataloging-in-Publication Data
Rayfield, Susan.
 Pierre-Auguste Renoir / Susan Rayfield.
 p. cm. — (First impressions)
 Includes index.
 Summary: Examines the life and work of this French
impressionist painter and sculptor whose work reflects
his joy in life.
 ISBN 0–8109–3795–6 (hardcover)
 1. Renoir, Auguste, 1841–1919—Juvenile literature.
2. Painters—France—Biography—Juvenile literature.
[1. Renoir, Auguste, 1841–1919. 2. Artists. 3. Art
appreciation.] I. Title. II. Series: First impressions
(New York, N.Y.)
ND553.R45R38 1998
759.4—dc21
[B] 98–12988

Printed and bound in Hong Kong

 Harry N. Abrams, Inc.
100 Fifth Avenue
New York, N.Y. 10011
www.abramsbooks.com

Page one:
Enfant au Polichinelle. c. 1874–75

Page two:
Luncheon of the Boating Party (detail). 1881

Right:
La Grenouillère (detail). 1869

Contents

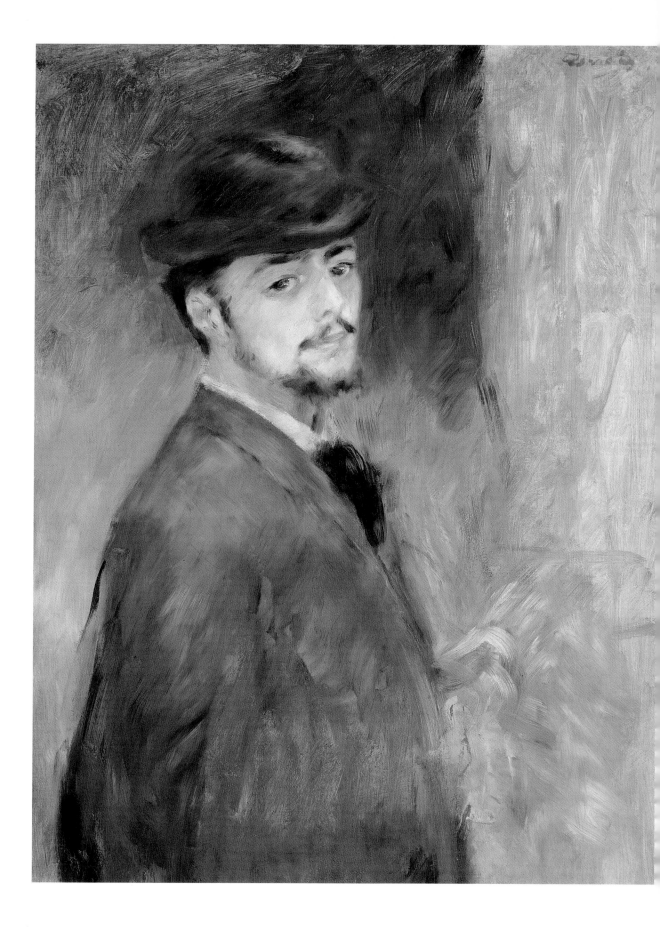

A Painter of Porcelain

When Pierre-Auguste Renoir was a boy, he played cops and robbers in the courtyard of the Louvre, former palace of the French kings. Nobody knew then, of course, that the Louvre would become a great art museum, and that the playful little boy would grow up to be a famous artist whose paintings would hang on its walls.

Renoir became a leader of the Impressionists, a group of painters named for the way they dabbed bright colors on their canvases, often blurring details to create a fleeting *impression* of the subject. Such daring stirred up criticism in their day—in the 1870s, people hadn't seen anything like it. Today, Impressionism is the most popular movement in Western art, and Impressionist pictures are among the most costly works of art in the world, selling for many millions of dollars. Of them all, Renoir's are perhaps the best loved.

Some say the name Renoir comes from the French word *reynard* (fox). There was certainly something foxlike about the artist with the light brown hair and amber eyes, whose slender five-foot-ten-inch frame seemed always on the move. A self-portrait at age thirty-five captures his intensity. His modesty, humor, and tendency to hum while he worked are harder to express in paint.

Renoir celebrated the joy of life, something the French call *joie de vivre*. His subjects were mothers and rosy-cheeked children, holiday outings, dances, concerts, and couples flirting in the park. Paintings that make you smile.

Self-Portrait. 1876
At thirty-five, Renoir still looks boyish in this unfinished self-portrait.
He often wore a hat to cover his thinning hair.

Few realize that this "happy painter," while creating masterpieces, suffered decades of poverty, pain, and scorn. For many years, critics made fun of his work, and few people would buy it. Those that did paid very low prices. Then, just as Renoir was beginning to achieve official acclaim, a devastating illness struck that would eventually disable him.

None of this, however, shows in his work. "For me a picture . . . should be something likeable, joyous and pretty—yes, pretty," the artist once said. "There are enough ugly things in life for us not to add to them."

Renoir was born on February 25, 1841, in Limoges, a town high above the wooded valley of the Vienne River in south central France, known for its porcelain. Christened Pierre-Auguste, he was called simply Auguste. His father, Léonard, was a tailor and his mother, Marguerite, a seamstress. There were three older siblings when he was born: Pierre-Henri, eleven; Marie-Elisa, seven; and Léonard-Victor, five. Later, a baby brother named Edmond came along.

When Renoir was four the family moved to Paris, three hundred miles northeast of Limoges, hoping to improve the tailor's faltering business. They settled in a neighborhood of narrow alleyways near the Louvre, where wash was strung on lines and the delicious aroma of sausages, herbs, and fresh baked bread from numerous family kitchens wafted on the air.

In those days, the streets of Paris were still lit with oil lamps, and the houses were heated with huge fireplaces. There were no hot- and cold-water taps or toilets. People relied on public carriers to bring water to their doors, and they relieved themselves in chamber pots.

The Renoirs' apartment building stood in a row of run-down homes built three hundred years earlier to house the families of noblemen and the palace guard. It was so crowded that little Auguste didn't even have a bed. Instead, he slept on the workbench in the parlor, bringing out his mattress and bedding after the day's work was done and his father had put away the rolls of cloth, yardstick, scissors, needles, and tailor's chalk that he used to make men's suits and ladies' gowns. Renoir didn't mind the hardness of the bench. What bothered him were the pins

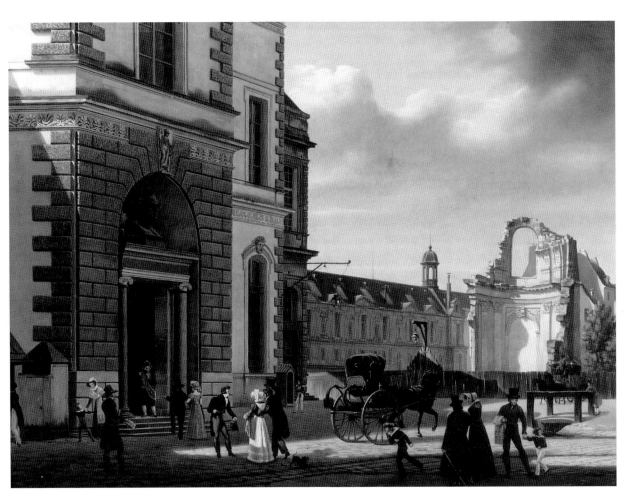

Etienne Bouhot. *Entrance to the Louvre Museum.* 1822
Artists like Renoir came to the Louvre to study and to copy fine paintings of the past.

scattered on the floor that stuck into his feet when he forgot to put on his slippers.

We know about the pins, the games of cops and robbers, and many other incidents from Renoir's life because his son Jean later collected these stories in a book called *Renoir, My Father*. As a child, Jean posed for many of Renoir's paintings, and when he grew up he became an artist, too—a famous filmmaker.

At the time Renoir turned seven, in 1848, a revolution was sweeping Europe, fueled by unhappy factory workers and an economic depression. The unrest knocked King Louis-Philippe off his throne. It wasn't the first time that French citizens had rebelled. Although France had been ruled by kings for centuries, a tendency toward democracy had simmered for fifty years before Renoir was born. Back in 1789, a mob of Parisians—enraged over unfair taxes, few jobs, high food prices, and the arrogance of the nobility—stormed the Bastille, the hated prison-fortress where so many had languished. It was the start of the French Revolution, which lasted ten years and awakened a passion for equality that continued to prompt uprisings for decades to come.

The 1848 revolution saw the king's troops firing on unarmed citizens in the streets of Paris. The people overthrew the king, and Napoleon III, a nephew of Napoleon Bonaparte, declared himself emperor of France, finally ending the long line of royal rulers. The

Vase, painted by Renoir. 1857
Renoir was a teenager working in a porcelain factory when he painted the design on this porcelain vase.

political upheaval had little effect on the Renoir family, however, who only noticed that the palace was empty one day.

Renoir attended a free, state-run Catholic school on the grounds of a convent. He studied in a cold, dark classroom, heated only by a wood stove. Frequently, the young student was made to stand in the corner because the light was so bad he had been unable to read the assignments in his book.

When he was nine, Renoir, who had a fine singing voice, joined the illustrious choir at St.-Eustache church. He also began to take an interest in drawing. In those days paper was scarce, so he scribbled all over the floors of his parents' apartment, using bits of charcoal and tailor's chalk to create portraits of his family, the neighbors, pets, whatever struck his fancy. Renoir's parents saw that he had talent and encouraged him.

At age fifteen, Renoir finished school, and it was time to learn a trade. Back then, it was impossible for the children of working people to go to college. After some discussion, his father found a place for him at a porcelain factory in Paris. He hoped that his son would carry on the proud tradition of their hometown, the porcelain center, Limoges.

Renoir began as an apprentice, learning from the more experienced workers around him. Soon he was happily decorating candlesticks and painting the borders around plates. When the owners saw his talent, they gave him more responsibility, allowing him to copy historical portraits. His favorite subject was Queen Marie Antoinette, wife of Louis XVI, who had been beheaded in public at the guillotine in 1793.

Next, he graduated to painting Greek and Roman goddesses on vases, copying figures in the paintings of such eighteenth-century French masters as François Boucher, Jean-Honoré Fragonard, and Jean-Antoine Watteau with an ease that would serve him well later on. To study these great painters of the past, he spent his lunch hours wandering through the Louvre, which by then had become the state museum.

Eventually Renoir mastered all the steps required to turn clay into fine porcelain: shaping the pieces on a potter's wheel, firing them slowly in a large kiln,

cooling them down, covering them with liquid enamel, refiring them at a much hotter temperature, applying the decoration, and then firing them for a third time. From start to finish, some thirty steps were required to create the finished product.

Renoir remained at the porcelain factory for five years. He might have stayed there for the rest of his life, but a machine was invented that stamped designs on porcelain, replacing handpainting and putting a lot of people out of work.

He found new employment painting designs on transparent screens. Then came a commission to decorate the walls of a local café. Customers came in droves to admire Renoir's mural of the goddess Venus rising from the waves. That success led to similar jobs at other cafés, which gave him the confidence he needed to become a professional artist.

During his twentieth year, Renoir attended classes at the state-run art school, the Ecole des Beaux-Arts, in the studio of the esteemed Swiss artist and teacher Charles Gleyre. The studio was a vast room crowded with young men (and a few young women), busily painting at their easels. Students studied perspective by copying engravings and paintings. They learned about anatomy by drawing from plaster casts and sketching live models. The women were not allowed to be in the studio with male nude models. They were ladies, after all. Because they were unable to practice drawing the human figure (the most important subject), their work was considered inferior.

Gleyre was preparing his pupils to enter their work in the official Salons—huge government-sponsored art exhibitions held in Paris each spring that attracted thousands of professional painters. In those days there were no private art galleries as we know them today. Being invited to show at the Salon was the only way to get noticed by the public and to make some sales.

Artists submitted up to three paintings to a jury composed of artists, art teachers, and elected officials. The jurists chose which paintings would be shown, where each would hang, and which artists would be awarded the prizes. Critics wrote about the paintings on display, and collectors bought art based on the critics' opinions.

The judges expected paintings to conform to what was called "high art." Historical paintings were at the top of the hierarchy. Also popular were paintings about Greek and Roman mythology—especially if they included nude goddesses, which gave men an opportunity to observe the unclothed female figure without embarrassment. Paintings to do with kings, Oriental themes, and famous stories in literature and the Bible came next, followed by portraits and still lifes. Landscapes were the least regarded.

The judges looked for realism. Colors were somber, with plenty of rich dark browns and blacks, applied smoothly, with no visible brushstrokes. In short, the closer a picture resembled a Rembrandt or a Rubens, the better its chances of getting accepted into the Salon.

Renoir had been studying at Gleyre's for a year when three new students joined the studio: Alfred Sisley, who was twenty-three; Frédéric Bazille, twenty-one; and Claude Monet, twenty-two. The tall Bazille came from a wealthy family in the south of France. Gentle Sisley was the son of an English businessman and a French woman who encouraged his art. Monet, a poor student from Le Havre, a port city on the coast of Normandy, nevertheless wore shirts with lace at the cuffs and was soon nicknamed "the dandy." Monet's confident air led him to become the leader of the group. Renoir called his friend "a born lord."

The group befriended two other artists—Camille Pissarro, thirty-three, and Paul Cézanne, twenty-four—who were studying at another art school, the Académie Suisse. Pissarro, who was ten years older than Renoir, was born in the West Indies and had a soft, musical voice. Cézanne was suspicious and withdrawn but had a special quality about him. "From the very start, even before I had seen his painting, I felt he was a genius," Renoir said about his grumpy comrade.

During the day they worked and visited each others' studios. In the evening, they met at local cafés to argue, laugh, and toss around ideas. They managed to eke out a living after art school by painting portraits of tradespeople, which they swapped for food or clothing when they couldn't get cash. "I remember especially the portrait of the cobbler's wife, which I painted in exchange for a pair of shoes," recalled Renoir. "Every time I thought the picture was finished and saw

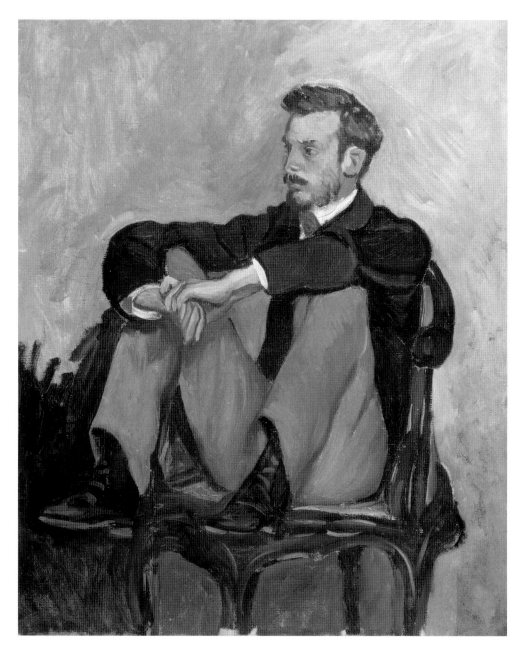

Frédéric Bazille. *Pierre-Auguste Renoir.* 1867

Renoir seems impatient posing for his friend, as though he wanted to hop off the chair and get back to his own work.

Opposite:
Frédéric Bazille at His Easel. 1867

Renoir painted this portrait in the studio that Bazille had rented for himself and the "needy painters" who were his friends: Alfred Sisley was working there on a still life of the same subject that Bazille is painting; Claude Monet's winter landscape hangs in the background. Edouard Manet, the group's unofficial leader, bought this portrait from Renoir.

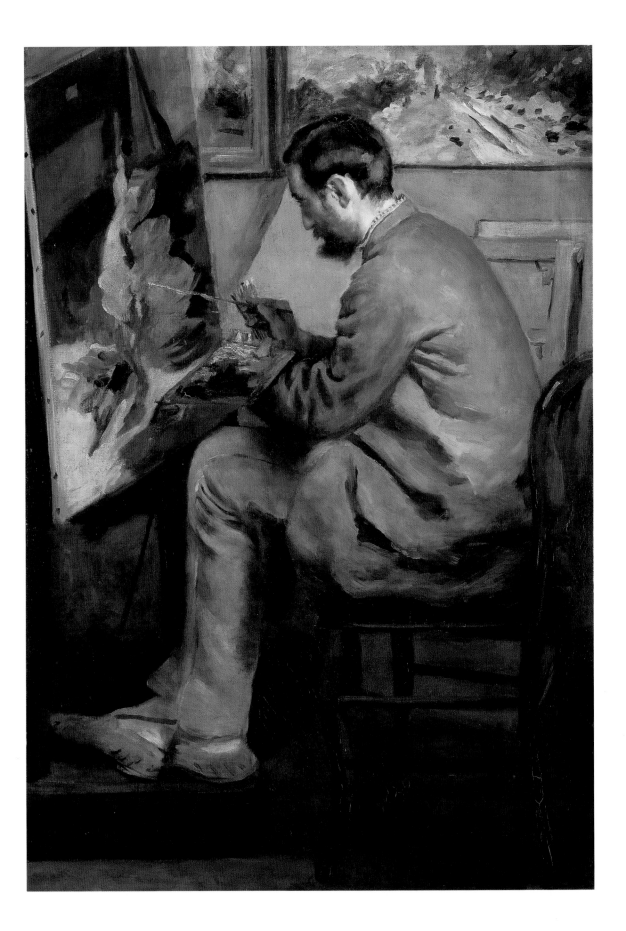

myself wearing the shoes, along came the aunt, the daughter, and even the old servant, to criticize."

When they weren't working on other people's portraits, they practiced painting each other. While Renoir was living at Bazille's studio in the rue Visconti, he made a portrait of his friend, dressed casually, big feet in slippers, working on a still life with a heron. Bazille in turn captured the nervous energy of his roommate in a small oil.

With the exception of Bazille, the group was very poor. When Renoir was evicted from an apartment, he left some rolled-up canvases behind as security. Renoir and Monet shared lodgings, and all the money they had went to pay for the studio, models, and coal for the stove, which heated their modest rooms and served to cook their beans. But it only took a few francs a month to live in those days, and they managed to get by.

Their friendships—particularly between Renoir, Monet, and Cézanne—were to last all their lives. They relied heavily on that strong group support in the hard days to come.

Spring Bouquet. 1866
Renoir loved pretty things. Flowers were a favorite subject throughout his life.

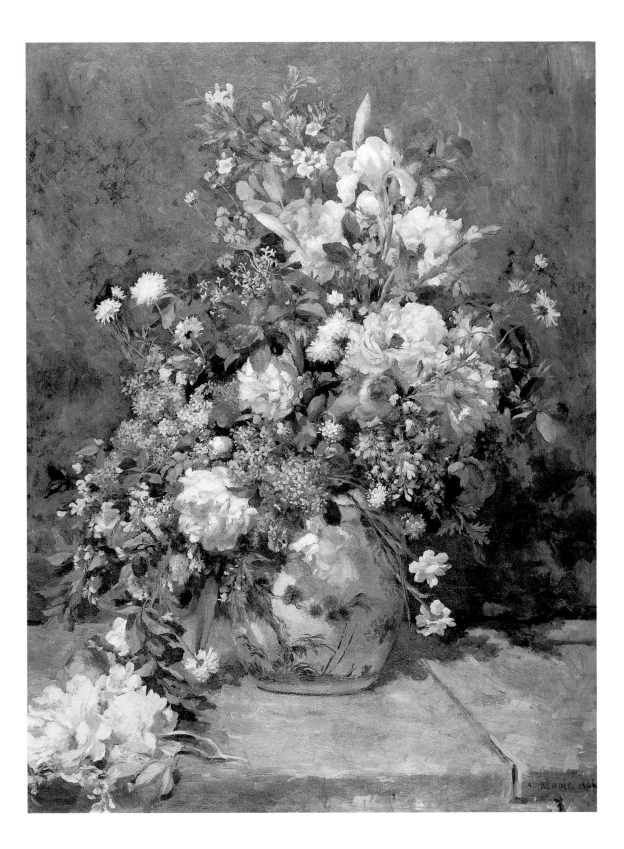

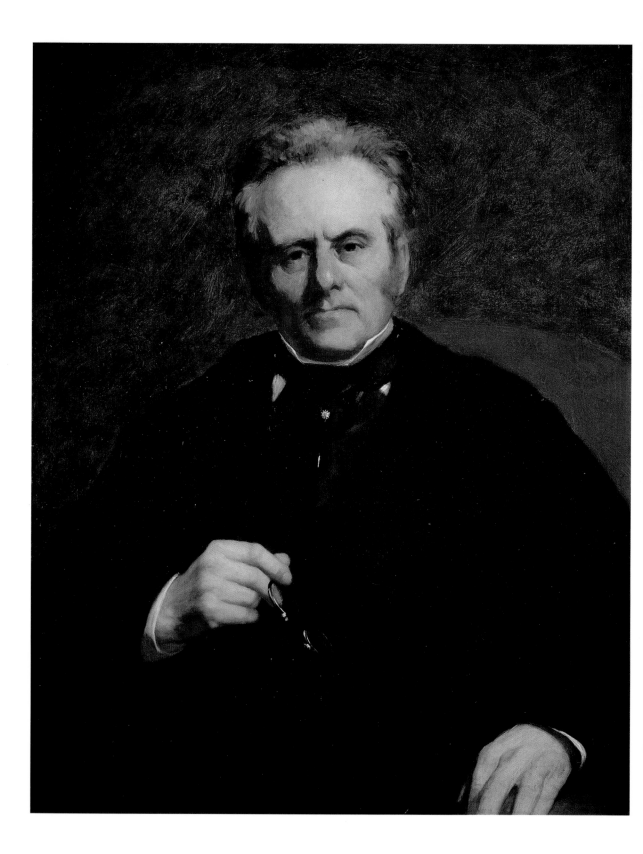

Beyond the Salon

*I*n the spring of 1863 Renoir submitted a painting to the Salon for the first time. It was rejected, but the following year his scene from a popular novel involving the hunchback of Notre Dame got in. Luck held the next year, too, when his portrait of Sisley's father, William Sisley, made the show. Its dark tones, smooth brushstrokes, and formal pose met the Salon's rigorous standards.

In 1866, Renoir again submitted to the Salon. He waited anxiously outside the exhibition hall to hear the decision of the judges. Pretending to be a "friend of the artist," he asked some departing jurists whether Renoir's work was in or out. "We're very sorry about your friend, but his painting was rejected," the well-known landscape painter Charles-François Daubigny informed him. "Tell your friend not to get discouraged, there are great qualities in his painting; he should get up a petition and ask for an exhibition of rejected paintings."

Renoir and his friends had little respect for the stodgy art encouraged by the Salon. "The big classic compositions are finished. The spectacle of daily life is much more interesting," Bazille exclaimed, with all the enthusiasm of youth. Nevertheless, they struggled to please the judges in order to see their art displayed and to promote sales. When Renoir's nude painted in the classical style, *Diana*, Roman goddess of the hunt, was turned down for the 1867 Salon, however, they learned

William Sisley. 1864
With dark, somber tones and careful attention to detail, this realist portrait captures the
stern character of fellow artist Alfred Sisley's father, a successful merchant. It was accepted
and exhibited at the Salon of 1865.

that even playing by the rules did not always work. A group of artists including Renoir petitioned for a show of rejected paintings, called a Salon des Refusés, but the government turned them down. When they tried to put on their own exhibition, funds fell through.

Meanwhile, a new, freer, more expressive way of painting beckoned. Two senior artists, Gustave Courbet and Edouard Manet, whose work was more accepted by the Salon jurists, had been experimenting with composition and color. Even before Renoir left art school, he had been exposed to their bold new ways of thinking. Courbet advocated painting out-of-doors, instead of in the studio, and using

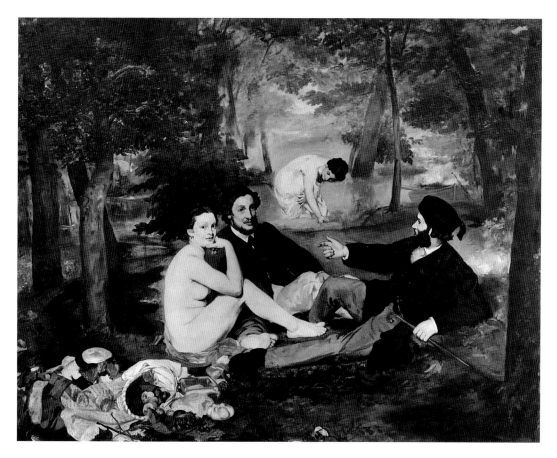

Edouard Manet. *Le Déjeuner sur l'herbe.* 1863
Because of its subject matter and technique, Manet's painting shocked critics and the public. Rejected at the Salon of 1863, it served, however, as a bold model of independence for Renoir and the other painters in his circle.

only subjects from nature, not grandiose and sentimental historical scenes. Renoir met Courbet and soon began painting outdoors himself.

Manet had an even greater influence on the younger generation. He painted modern themes and used sketchy brushwork; both were revolutionary at the time. He discarded the approved practice of toning down bright colors and using lots of dark shadows. Instead, he put pure colors side by side, without gradation, achieving a daring "flatness." Manet's most recent subject matter scandalized Paris. *Le Déjeuner sur l'herbe* (Luncheon on the Grass) featured a picnic with two couples in which the men were fully dressed in contemporary clothes and one of the women was nude. Although undressed goddesses were accepted, nudity in a modern setting was considered indecent. *Le Déjeuner* seemed to be mocking the Salon, which rejected it. Manet championed his ideas at the Café Guerbois, where Renoir and his friends gathered. The younger generation listened attentively and practiced the new techniques as often as they could.

Under Manet and Courbet's influence, Renoir painted *Lise with a Parasol*, his first life-size figure painted outdoors, in which a stylish young woman waits for her date at the edge of the Fontainebleau Forest. The model was Renoir's mistress, Lise Tréhot. By painting her face in shadow, he may have been making a statement about her social status. In those days, it wasn't quite respectable for a woman to wait alone in a public place for a date. Despite its daring, *Lise* was accepted by the Salon of 1868, where it attracted both praise and scorn.

Renoir's entry the following year, another portrait of Lise called *Study: In the Summer*, was also accepted, but it was hung so high on the wall, near the ceiling, that it was hard to see. It received no attention in the press, and, as far as the buying public was concerned, it might as well never have existed. That was unfortunate, as Renoir was broke. He was forced to return to his parents' home, but at least he wasn't in as much trouble as Monet, who had a wife and a baby to support. Renoir brought Monet's family some of his mother's bread to keep them from starving.

In 1869, Monet and Renoir painted together at La Grenouillère (The Frog Pond), a popular eating, bathing, and boating spot on the Seine River, just outside

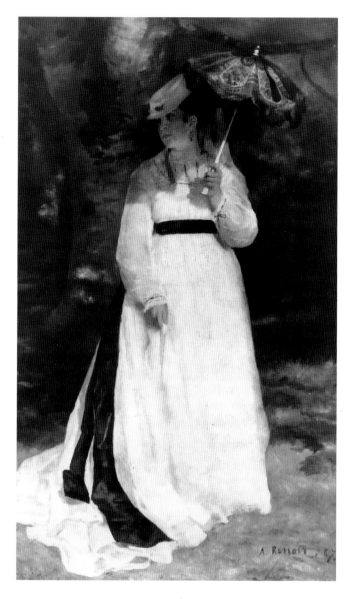

Fromage en promenade et d'une bonne pâte, par RENOIR.

Lise with a Parasol. 1867

Caricature by Gill. 1868

Lise was mocked by cartoonist Gill, who pretended that the model's head, which was hard to see in the shadows, was missing altogether. To him, the painting looked like "a nice semi-soft cheese out for a stroll."

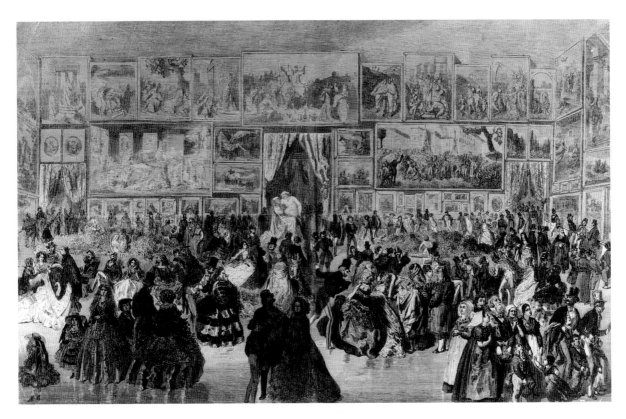

The Salon of 1868
So many artists participated in the Salons that paintings were hung all the way to the ceiling, a method of display called skying.

Paris. City couples liked to gather there for a day's outing in the countryside. The women wore dresses with bright ribbons and carried parasols; the men looked dapper in striped trousers and high hats.

Their link to the country was the newly invented railroad. Before, people were limited to renting a vacation house, staying in a hotel, or traveling to a rural town for a single day. They got around on bicycles, or took walking tours. As the number of train lines increased, once-remote settings were now just a short ride away, and hordes of middle-class Parisians rushed to visit riverside cafés, rural swimming places, and picnic spots. Ordinary people could afford weekend excursions because factory and railroad jobs were plentiful and the wages were good. The elegance of the women coincided with the founding of department stores, which

made fashionable clothes affordable. "The world knew how to laugh in those days!" Renoir later recalled. "Machinery had not absorbed all of life; you had leisure for enjoyment and no one was the worse for it."

At La Grenouillère, there were booths on the shore for people to change into bathing suits, and sailboats and rowboats were moored all around. The restaurant rested on a floating barge, connected to a little island known as Camembert because its shape resembled that small, round French cheese. Both the island and the barge were reached by means of rickety footbridges, adding to the fun.

The artists set up their easels side by side, yet each saw a slightly different scene. Monet, a landscape painter at heart, focused on the island itself, framed by dark ripples and the bright distant shore. Renoir, who preferred to paint people, chose a closer view that emphasized the figures. In his painting, a woman on a foot-bridge talks to a boy dressed for swimming, perhaps a mother warning her son not to go out too far. On the little island, a man kneels to secure a boat, while a dog sleeps in the sun. None of the small, ordinary details got past Renoir's sharp eyes.

Imagine what onlookers must have thought as they peered over the shoulders of these two artists who painted so strangely. Rapid dabs of gold caught the sunlight sparkling on the water and dancing through the trees. Dashes of blue and green made the ripples. People were defined by mere squiggles. Two quick, confident strokes became a pair of oars. No Salon judge would approve of that!

Renoir submitted two conservative paintings to the Salon of 1870 that were designed to please the jurists and to make money. *Bather* echoed Greek sculpture, and *Woman of Algiers* (see page 52) employed the ever-popular Oriental theme. Both were accepted.

Opposite above:
Claude Monet. *La Grenouillère*. 1869

Opposite below:
La Grenouillère. 1869
Painting outdoors with Monet helped Renoir to loosen his brushstrokes and to develop the freer, softer style shown here.

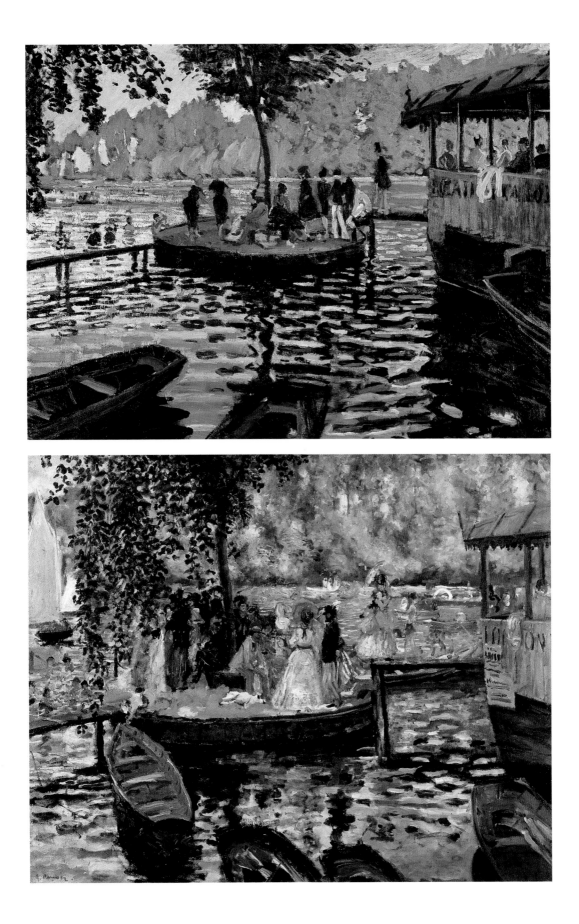

That same year, working in the new, fluid style that pleased him more, Renoir completed his first big figure paintings: *Nymph at the Stream* and *The Promenade*, where flickering, shimmering brushstrokes conveyed light and shade. Renoir was coming into his own as a professional artist, but his personal life was about to change abruptly.

In the summer of 1870, France unexpectedly declared war on Germany, and the group of artist-friends scattered. Renoir was drafted into the battalion of the Tenth Cavalry Regiment and spent four months in the army before he was discharged with dysentery and severe depression. Cézanne hid in Marseilles. Monet and Pissarro, who had families to support, escaped to London. Bazille, who was only twenty-nine, the same age as Renoir, died in battle. Just after the war of 1870 ended, Paris erupted in civil war. Renoir fled the city with his family, only returning after peace was finally restored.

From 1871 on, Renoir, Monet, and the others in the group knew that they were painting in an important new way. Working *en plein air* (in the open air), they sought to capture a fleeting moment when the light, the colors, and the forms were just so. Their brushwork was getting looser, and the colors brighter, with every painting. Uninterested in details, they dashed down just what could be seen at a glance. They encouraged each other in their discoveries and, when they could, bought each other's work.

The artists were bolstered by a small circle of private collectors who were convinced from the outset of the group's importance. The first collector of Renoir's work was a wealthy young architect and painter named Jules Le Coeur, who befriended Renoir and invited him often to the family's several homes. Other early friends and collectors were the art critic Théodore Duret, George Bellio (a homeopathic physician who treated the illnesses of Manet, Pissarro, Monet, Sisley, Renoir, and their families over the years), and fellow painter Gustave Caillebotte. They lent Renoir money, helped him find other patrons and commissions, and even posed for him. More importantly, they bought "all the stuff we had at our studios that had been ordered and never called for," according to Renoir.

In 1873, Monet introduced Renoir to Paul Durand-Ruel, one of the few pri-

The Gust of Wind. c.1872
Critics objected to the sketchiness and lack of finish in works such as this one. They did not
understand the artist's desire to capture the blustery effect of a sudden high wind.

vate art dealers, with galleries in Paris and London. Durand-Ruel took an immediate liking to Renoir and bought three paintings from him. The dealer championed the upstart group and had the courage to represent many of them. They would come to rely on the sale of their works at his galleries and auctions, as well as the "loans" he provided during the lean times in between.

Earlier, in the summer of 1872, Renoir began a series of long, pleasant visits with the Monets at their home in Argenteuil, a small town on the Seine, twenty minutes from Paris by train. He and Monet practiced their new style by painting the scene around them—boats on the river; Monet's wife and son, Camille and Jean, relaxing in the garden; Camille reading a newspaper. It was an idyllic time.

Madame Monet Reading "Le Figaro." 1872
Renoir deliberately made everything blurry in this Impressionist portrait of Monet's wife, Camille,
to focus on the delicately rendered features of her face.

Back in Paris, Renoir continued to try to appeal to the Salon audience. Even so, his huge canvas, *A Morning Ride in the Bois de Boulogne* (see page 31), portraying two upper-class figures on horseback, was rejected in 1873, despite being the "right" style and subject matter.

In 1874, a worldwide economic depression forced Durand-Ruel to stop buying pictures and to close his London gallery. To make matters worse, Renoir was rejected by the 1874 Salon, as were most of the others in his group. Fed up, along with some thirty other rejected artists, they decided to stage a private exhibition

at 35, boulevard des Capucines, at the former studio of the celebrated photographer Nadar. The show opened on April 15, 1874, less than two weeks before the official Salon opened its doors. Viewers were aghast. Before them were ordinary scenes of everyday life (where were the Greek gods and goddesses?), rendered with disconnected strokes and garish blobs of color so bright they hurt the eyes. Viewers complained that the works looked unfinished. Didn't these artists know how to paint any better? They must be putting on the show to purposefully offend the public. Or maybe they were lunatics.

The exhibition included paintings by Pissarro, Sisley, Edgar Degas, Cézanne, Berthe Morisot (the only woman in the group), Armand Guillaumin, Renoir, and Monet. Renoir submitted several important new works: *La Loge*, *The Dancer*, *Harvesters*, *The Parisienne*, *Flowers*, and *Head of a Woman*. Among Monet's work was a small, sketchy view of two boats leaving Le Havre as a red morning sun rose through the mist. Stumped for a title, at the last minute, he chose to call it *Impression, Sunrise*.

"These Impressionists!" snorted a critic. Even though it was meant as an insult, the artists took the name proudly as their own. After all, for years they had described their work as capturing the *impression* of the moment. From then on, they were Impressionists. And so, the best-known and best-loved movement in Western art had its beginning.

That spring Renoir was so poor he had to appeal to friends to survive. "I shall be very grateful to you for not forgetting me this month because I'm in a bottomless pit," he wrote to his friend Théodore Duret. The next year, when his canvases were again rejected by the Salon, Renoir confided to another friend, "I must find 40 francs before noon and I have exactly 3 francs." Not even enough money for a pound of coffee.

To raise funds after the failure of their first show, the group decided to hold a public sale at the Hôtel Drouot, which had been converted from a hotel to an auction house. The sale opened on March 24, 1875, and was even more unpopular. To Renoir's amazement, the public attacked the art with walking sticks and parasols, disrupting the auction so much that the police had to be brought in to restore order.

The important critic Albert Wolff declared in the newspaper *Le Figaro:* "The impression made by the Impressionists is that of a cat walking on the keys of a piano, or a monkey that has got hold of a box of paints." So few paintings sold that the artists ended up owing money to the auctioneers.

Renoir's paintings were practically given away, but, despite that, the event turned out well for him. His work attracted the attention of Victor Chocquet, a civil servant and art collector, who found in Renoir's colorful canvases a resemblance to the work of his favorite artist, nineteenth-century Romantic master Eugène Delacroix. Chocquet immediately commissioned Renoir to do a portrait of his wife. He continued to acquire Renoirs, and the two men became good friends. Also at the auction was the publisher-tycoon Georges Charpentier, who purchased three Renoirs and invited the artist to his home. Charpentier was to play a major role in Renoir's future.

The second Impressionist exhibition opened in April 1876 in Durand-Ruel's gallery. If the critics and public considered the first show a joke, now the joke had gone too far. Even fewer visitors came. Renoir sold no paintings at all.

The third Impressionist show, held in 1877, attracted only eighteen painters. Viewers described feeling seasick and thought that the artists must have painted with their eyes closed. Each day of the month-long exhibition about five hundred viewers showed up, but most came just to laugh.

Stung by poor sales and scoffing audiences, Renoir, now thirty-six and desperate to be accepted by the next Salon, gave up trying to promote Impressionism and returned to painting portraits almost exclusively. For the first time, he put his own needs above his ideals and loyalty to his friends. Although he seemed to desert them, they remained sympathetic. "It's a matter of a hungry belly, an empty purse," explained Pissarro. Renoir was not alone in the decision. At about this time Sisley, Monet, and Cézanne stopped exhibiting with the other Impressionists and concentrated on showing at the Salon. In 1878, Renoir was accepted for the first time in eight years, with a painting of a seated woman at a table called *A Cup of Chocolate.* That fall, he began work on a commission from the Charpentier family that would catapult him into the limelight at last.

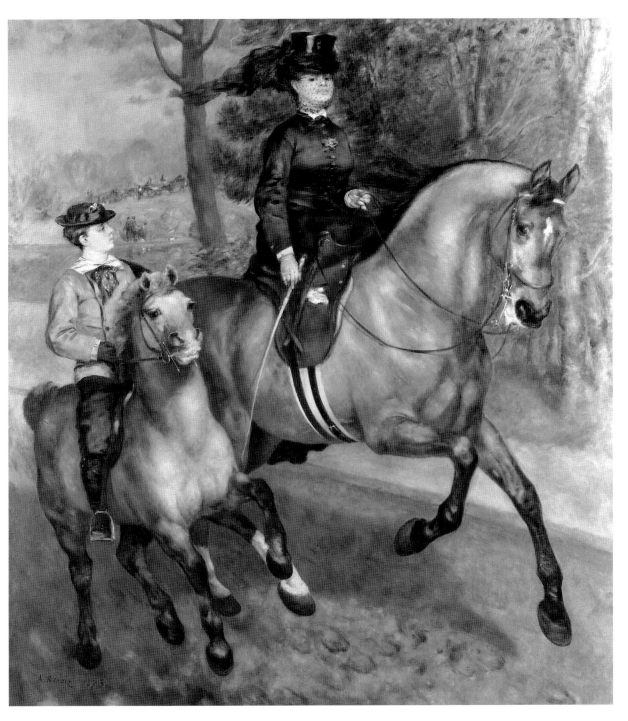

A Morning Ride in the Bois de Boulogne. 1873
Renoir studied horses in motion at a military riding school in preparation for this portrait of an
elegant horsewoman and a young boy. The artist used his sketches later when he painted the people
in the studio with an artificial landscape backdrop.

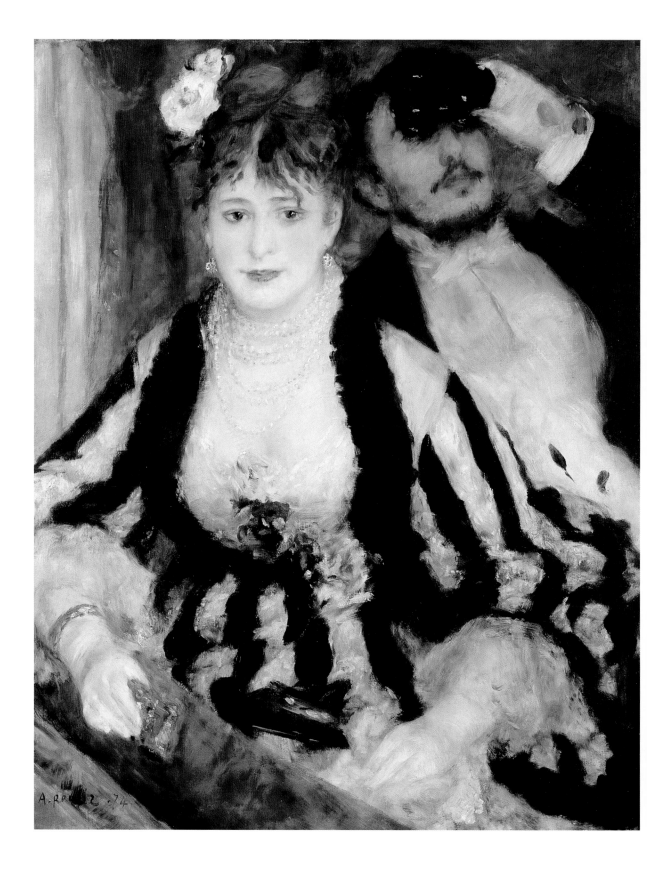

A Celebration of Color

Shimmering pinks, luminous whites, translucent greens, yellows, purples, and blues. These are the colors of the Impressionists. The hues of nature. The palette of Renoir.

For the Impressionists, color, light, atmosphere, and movement were everything. Be it sun-spangled leaves, the dapple of shade, glittering water lights, the drift of a woman's dress—these fleeting moments must be captured quickly or not at all.

The Impressionists were aware of the findings of color theorist Michel-Eugène Chevreul, who in 1839 first published his famous color wheel—a circle of colors grading from yellow to orange, red, violet, blue, blue-green, green, green-yellow, and yellow again—demonstrating how neighboring colors influence each other. The Impressionists did not approach painting as a science. They studied sunlight in the open air. They saw how colors were modified by their surroundings: a white dress on a green lawn takes on a greenish tinge, a snowbank at sunset is tinted pink. They learned that by placing contrasting colors (those opposite each other on the color wheel) side by side—such as red next to green and orange beside blue— the colors seemed to vibrate and appeared even brighter. They observed that when small dabs of paint were viewed from afar, the reflected light rays merged, and the viewer's eye mixed the colors. Light was essential. Renoir sought models whose

La Loge. 1874

The theater was a center of social life in Renoir's time and was an attractive subject for artists because of the elegant and colorful dress of the audience, the dramatic lighting, and the sense of excitement in the air.

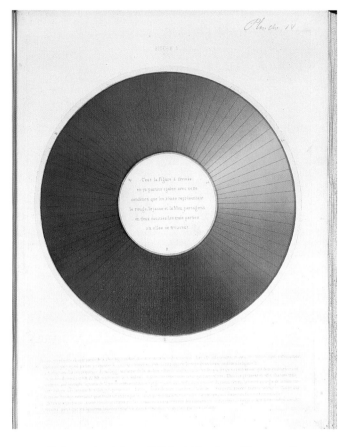

Color wheel from Michel-Eugène Chevreul's
*On Colors and Their Applications to the
Industrial Arts.* 1864
The Impressionists used complementary colors,
opposite each other on the wheel, to create dazzling
effects. Their flair for color made their paintings
seem to vibrate with life.

glowing complexions "took the light." "The devil of it is that light changes so quickly!" he said. Even shadows were drenched with light—painted in transparent violets and blues instead of adding black.

The artist's palette, a flat wooden tray on which he heaped little mounds of paint, contained just a dozen or so colors, arranged neatly along the edge. He once drew up a list of the names of some of the pigments that he especially liked: flake white, chrome yellow, Naples yellow, yellow ochre, raw sienna, vermillion, rose madder, viridian green, emerald green, cobalt blue, and ultramarine blue. He favored flat hog-hair brushes for most of the painting and pointed sable brushes for fine details.

Jean Renoir often prepared his father's canvases and watched him paint. He noticed how the artist would begin by making tiny pink or blue strokes directly on the white canvas, creating a background that made the colors seem even more brilliant. (Artists before the Impressionists first washed dark tones over the white surface, then painted their pictures on top of that.) Like his colleagues, Renoir used

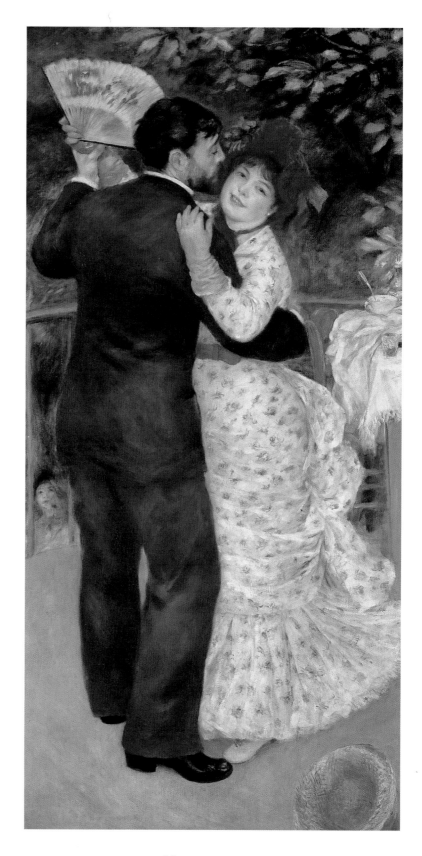

Country Dance. 1883
Renoir often returned to the
theme of Parisians enjoying
themselves in the country.
The smile and the outward
glance of this young woman
(Aline Charigot) draws the
viewer into the scene.

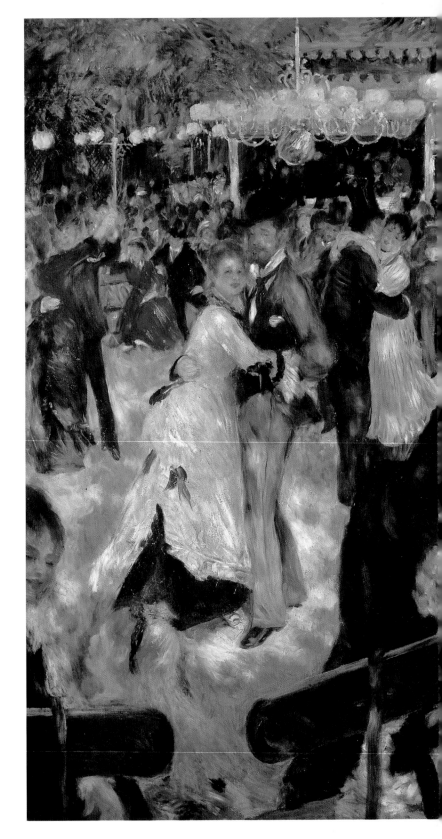

Ball at the Moulin de la Galette. 1876
Renoir used artist-friends and local working-class girls who frequented the dance hall as models. The Moulin de la Galette was really a rather shabby place, but the artist creates a charming tableau, bursting with youth and energy, color and music. Renoir cropped the edges of this lively scene to make it appear that the action continues beyond the frame.

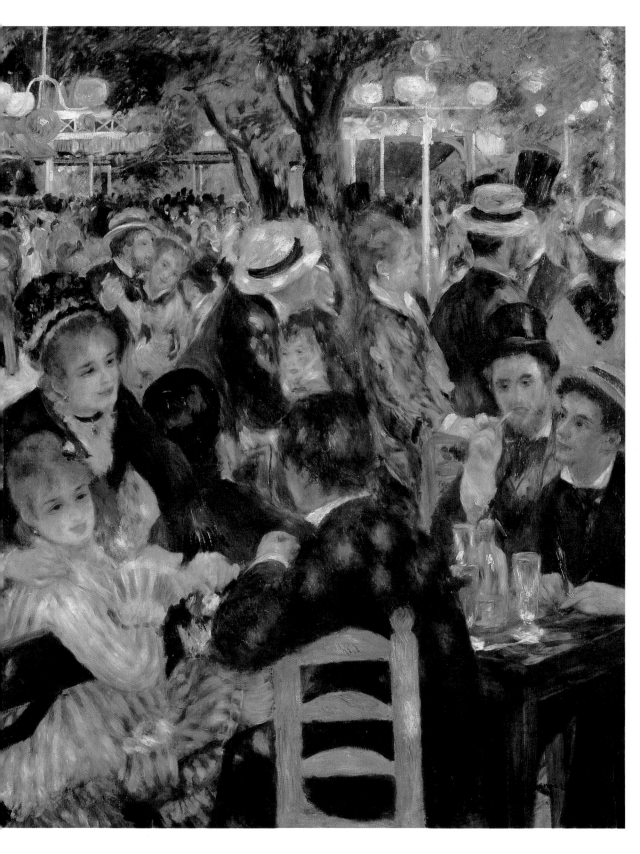

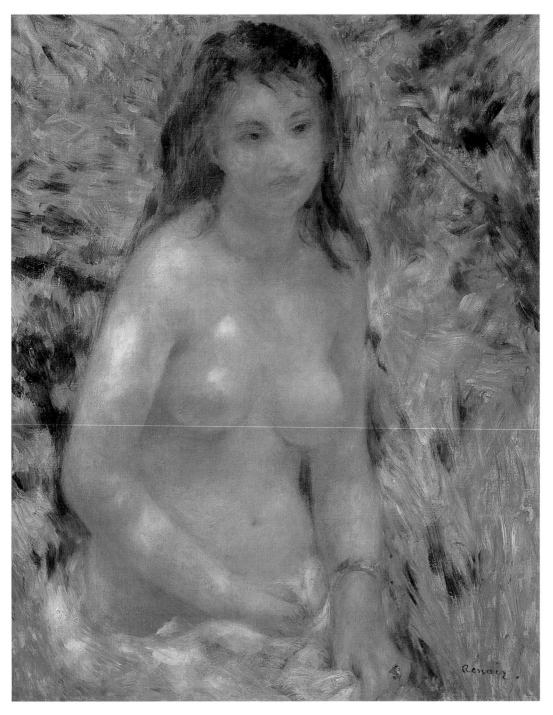

Nude in the Sunlight. 1875–76

It was the Impressionists' treatment of shadows as filled with color rather than as dark patches that brought them the most scorn. This nude in dappled shade was described by one critic as a "mass of decomposing flesh with green and purplish spots."

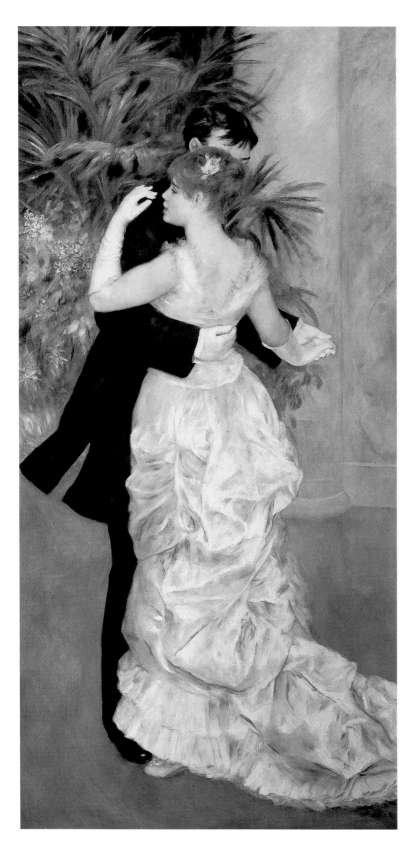

City Dance. 1883
The couple in this cool, for-
mal setting look quite unat-
tached to one another, as if
they would go their separate
ways after the music ends.

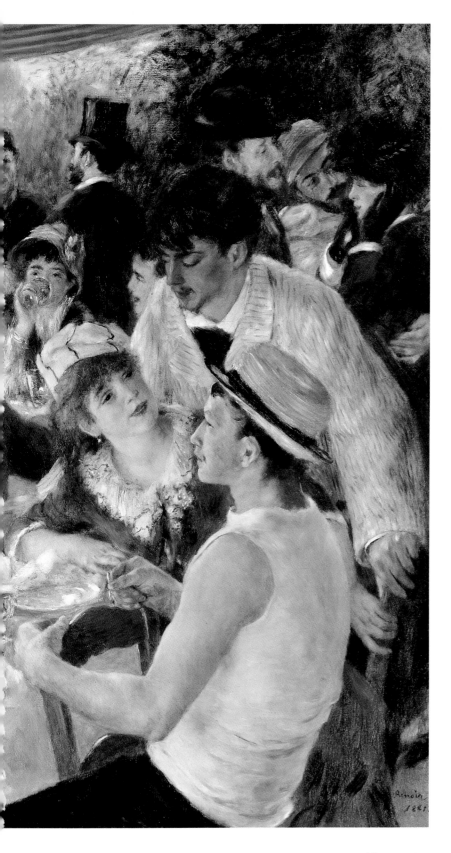

Luncheon of the Boating Party. 1881
Five years after completing the *Moulin de la Galette*, Renoir painted this follow-up, a lighthearted summer scene on the terrace of a riverside restaurant. Here, he has paid more attention to depicting individual faces, with distinct features. In the upper right, an oarsman appears to be teasing a proper young lady, who covers her ears. Or perhaps she's simply adjusting her hat?

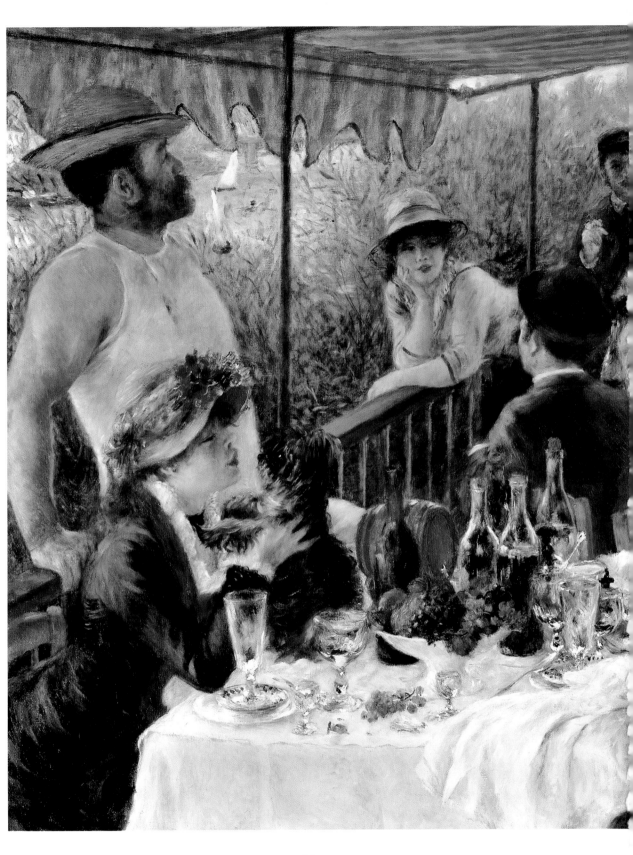

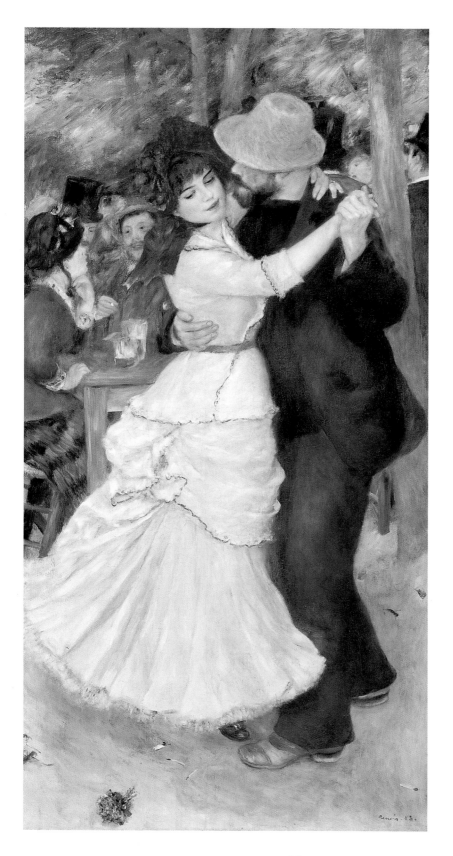

Dance at Bougival. 1883
Renoir conceived
Country Dance and *City
Dance* as a pair. *Dance at
Bougival* was meant to be
displayed independently.
Viewed together, however,
the couples in these three
life-size paintings seem to
swirl to the same music.

pure, rather than mixed colors. He blended his paints right on the canvas wet into wet, adding one next to the other before they dried.

After making the background, Renoir might add a yellow and, perhaps, a strong, rich red. "I want my red to sound like a bell," he once said. Slowly the figure of a model or the outlines of a landscape would appear, brought to life by the artist's short, rapid brushstrokes. Powerful black—avoided by the other Impressionists but embraced by Renoir as "the queen of colors"—was reserved for last. "The older I grow, the more I love black!" he maintained. "You break your neck trying to find the right color; then you put in a little touch of 'ivory black'—and there you are!"

The artist used thinned paint for skin tones, applying it with smooth, delicate strokes. As he built up the picture, certain strokes were applied more heavily. Final details were applied so thickly that they rose above the surface of the canvas in an effect called impasto.

Renoir took sheer delight in painting. As he laid a sharp stroke here, a rounded dab there, he chatted to his model or got so caught up in his subject that he often seemed unaware of what went on around him. On the other hand, if he did not like the way a painting was going, anybody could tell: he vigorously rubbed the side of his nose.

We can trace how Renoir used his knowledge of color by looking at some of his most famous paintings, executed in a burst of creativity between 1874 and 1883.

La Loge (The Theater Box; see page 32), which was shown at the first Impressionist exhibition, was a tribute to black. It sets off the woman's delicately powdered white skin and gold jewelry, gives her escort a dramatic impact, and adds elegance to the scene. Surprisingly, the areas in shadow—the folds of her dress and the front of his shirt—show no black at all, but rather soft purple, and even some pink and cream!

Here, a pretty woman, dressed in her finest, looks out at the viewer, aware that she is being "seen," while her escort tips his opera glasses upward, observing spectators in the boxes around him. The woman is Nini Lopez, whose friends teasingly called her "fish mouth," probably because of her small, pursed lips. The man

is Renoir's younger brother Edmond, who frequently posed for him. It could just as well have been the artist himself. Whenever he went to the theater—which wasn't often—Renoir, too, enjoyed the spectacle around him more than what was happening on stage. In fact, Renoir hated to see the theater darkened. "You are forced to look at the only place where there's any light: the stage. It's absolute tyranny. I might want to look at a pretty woman in a box," he said.

Shortly after it was painted, Durand-Ruel exhibited *La Loge* in London, then returned it to the artist, who sold it to another dealer for 225 francs. Twenty-four years later, Durand-Ruel bought the painting back for 7,500 francs. In 1912, it fetched 31,200 francs, and in 1989, *La Loge* sold for $12.1 million at Christie's auction house in New York. It is one of the finest Impressionist masterpieces.

Another of Renoir's great paintings completed about this time was *Ball at the Moulin de la Galette* (see pages 37–38). The name refers to an outdoor dance hall and café in Montmartre, a section of Paris where shopgirls and clerks gathered on weekends to dance and have a good time. By the early 1900s, Montmartre would attract hordes of artists and become known for its bohemian way of life. In the mid-1870s, it was still a simple village, however, inhabited by workers' families. The Moulin de la Galette was located at the foot of two of the area's remaining windmills, from which it took its name: *moulin* means mill, and *galette* is the delicate French pastry that was the speciality there.

Determined to capture the excitement of the whirling scene, Renoir painted his picture in the midst of the dancers. It was a difficult task, since the canvas on which he chose to make a study was two-and-a-half feet high and almost four feet long. Friends had to help him carry it through the streets, back and forth, every day, from his studio to the dance hall. "This was not without difficulties, when the wind blew and the canvas threatened to fly away like a kite," a friend later recalled.

Renoir needed models. As soon as he moved into the neighborhood, he began to hire seamstresses, laundresses, and other local girls to pose for him. Fellow artists and other male friends posed as well. Seated in the midst of the swirling couples, Renoir captured their noise and laughter, their bragging and flirtations. He also caught the trembling sun as it shone through the thin foliage, and the glowing

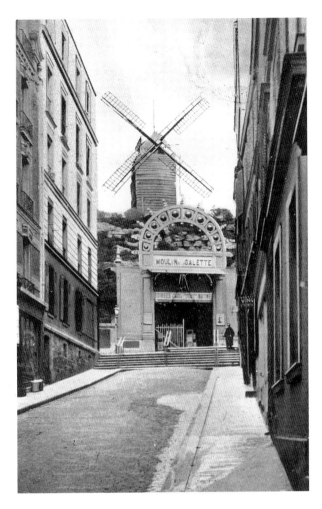

The Moulin de la Galette

Chinese lanterns overhead that dappled the dancers with rounds of light.

In addition to the large preparatory painting, Renoir made a small oil study of the entire scene and several oil studies of the dancers. The final version was so big—more than four feet high and almost six feet long—that it had to be completed at Renoir's rented studio in the rue Cortot. The models came to pose in the garden.

The painting shimmers with color—pinks and yellows, purples and blues—creating the impression of movement. True to the Impressionists' credo, even the shadows are made up of colors, which caused one critic to lament that the figures were "dancing on a surface which looks like the purplish clouds that darken the sky on a thundery day." Others, however, thought it was a *tour de force* (a feat of strength, skill, or ingenuity). No one had ever tried to capture a contemporary outdoor scene on such a grand scale!

Shortly after completing *Moulin*, Renoir painted a smaller picture called *The Swing*, featuring one of the same models, dressed in the same fashionable gown that she wore as the main dancer in *Moulin*. Again, Renoir focused on the dappled light and shade. And again the critics responded harshly—this time calling the effect "spots of grease." Happily for the world, Renoir's friend and fellow Impres-

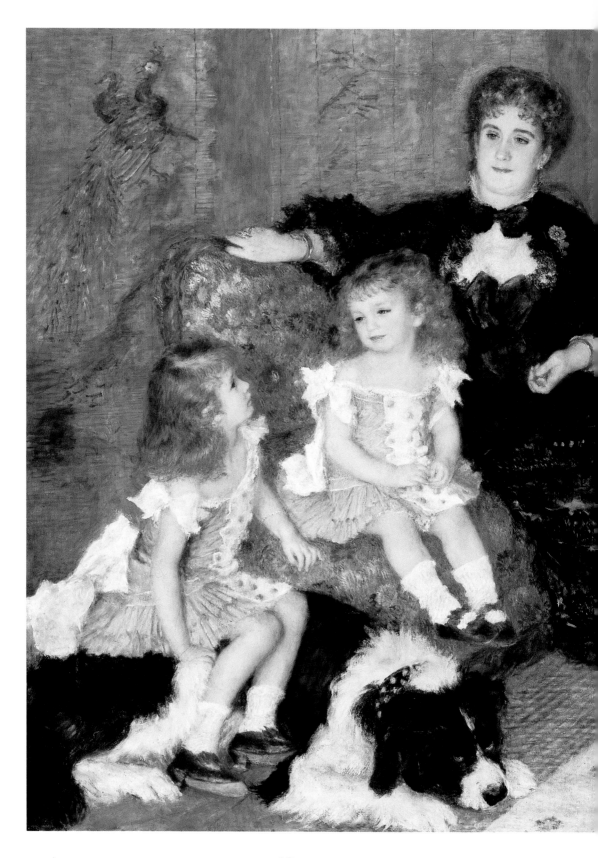

sionist Gustave Caillebotte liked *The Swing* and bought it, later bequeathing it, along with the rest of his collection of Impressionist paintings, to the Louvre.

In 1878, Renoir began work on the painting that would gain him wide attention at last—a large portrait of Madame Marguerite Charpentier and her two children. The publisher's wife was renowned for her evening salons, in this case, social gatherings of celebrities from the world of politics, literature, theater, music, and art. The best talent in all of France came to her salon, including novelists Emile Zola, who was also a journalist and champion of

Madame Charpentier and Her Children. 1878
Renoir enjoyed painting Madame Charpentier's shimmering satin dress. Unlike the other Impressionists, who preferred light tones, one of Renoir's favorite colors was black.

the Impressionists, and Gustave Flaubert, the author of *Madame Bovary;* as well as the legendary actress Sarah Bernhardt. Manet, Monet, and Renoir were frequent guests. Renoir even dubbed himself the Charpentiers' "artist-in-waiting." Once he absentmindedly showed up for dinner without a jacket and Georges Charpentier had the other men take off their jackets so that the artist would not feel embarrassed.

In the portrait, Madame Charpentier is seated in the parlor of her elegant Parisian town house. Next to her is three-year-old Paul, dressed like a girl, as was the custom at that time. Six-year-old Georgette sits on top of their big Newfoundland dog. Renoir encouraged Madame Charpentier to relax and pose comfortably— a good thing, because the painting took him a month and a half to finish and required forty sittings. Once again, the color black dominates, setting off the blue outfits of the children and blue's complementary color, orange, found in the rug and in the background.

Renoir saw the portrait as an opportunity to finally show the Salon judges what he could do. They thought his technique was sloppy? Well, he would make this painting's surface smooth as glass, with hardly a brushstroke to be seen. They said his drawing was bad? This time the figures would be rendered with extraordinary care.

The Charpentiers were pleased with the result and paid Renoir 1,000 francs for it, a lot of money in those days. Madame Charpentier displayed the painting at her salon, where it received wide attention, and used her influence to make sure that it was hung in a prominent position in the 1879 Salon exhibition.

In deference to her social position—and Renoir's seeming abandonment of Impressionism in favor of Salon techniques—critics were more forgiving than usual. "We must not pick quarrels with M[onsieur] Renoir; he has returned to the bosom of the Church," wrote the reviewer Arthur Baignières. "Let us forget about form and simply talk about coloration." Faint praise, but praise nonetheless. Finally, everyone was talking about Renoir. Today, the painting *Madame Charpentier and Her Children* hangs in the prestigious Metropolitan Museum of Art, in New York City.

In the fall of 1879, Renoir met Aline Charigot, an auburn-haired seamstress, who lived with her mother near the artist's studio in Paris. She began posing for him, and soon they fell in love.

For thirty-eight years Renoir had lived a bachelor's life. Now a twenty-year-old, strong-minded country girl from a village in Champagne changed all that. Together, they strolled along the banks of the Seine and took trips into the countryside. One of their favorite haunts was a restaurant on the small island of Chatou, just twenty minutes from Paris by train.

The restaurant's owner, Alphonse Fournaise, was an avid oarsman who rented boats to his customers. The Restaurant Fournaise had become something of a boating club. Renoir loved the festive spirit of the place and had planned to do a painting of people lunching on the terrace for some time, as a sequel to *Moulin*. In 1881, he began a larger-than-life painting of the eatery, as usual enlisting friends to pose for him. Aline, by now his fiancée, is shown in a yellow straw hat decorated with red flowers, cuddling a little dog. Caillebotte sits backward in a chair across the table. Above her, Fournaise himself proudly surveys the happy scene.

Once again, opposite colors on the color wheel—orange and blue, red and green—painted beside each other brighten the scene. And, in true Impressionist fashion, the shaded portion of the white tablecloth and napkins are made up of a myriad of flickering, reflected hues. A high point of Renoir's career, *Luncheon of the Boating Party* (see pages 39–40) can be seen today at the Phillips Collection in Washington, D.C.

Renoir loved romance and returned to the subject many times. In 1883, he painted three of his most famous paintings—life-size panels of couples dancing, in the country and in the city. The theme, the bright palette, and the feathery brushstrokes are all hallmarks of Impressionism. *City Dance* depicts an elegant upper-class couple in evening dress. Some believe the couple in *Dance at Bougival* is a larger version of the pair at the center of *Ball at the Moulin de la Galette*. Aline posed for the girl with the fan in *Country Dance*. In the arms of the artist's friend Paul Lhôte, she seems to be smiling right at Renoir.

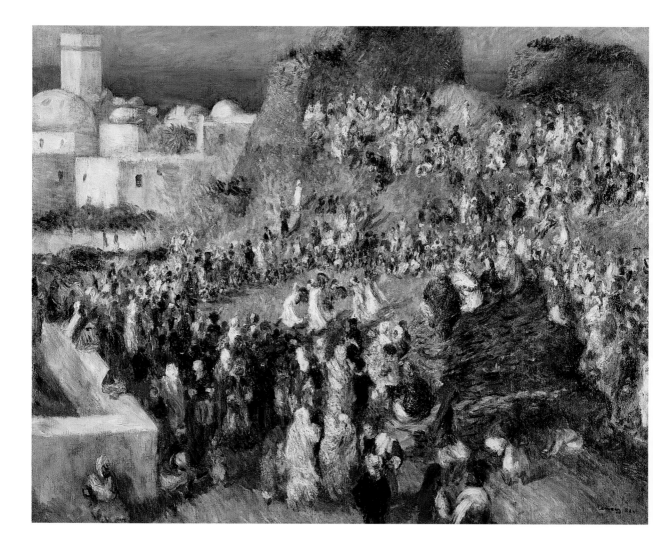

"What a Trip!"

*I*n *1881, Renoir turned forty and paused to examine his life.* He was not where he wanted to be. Portrait commissions were going well, but few people seemed interested in buying other subjects. Had his hard-fought battle to break new ground been in vain? He was beginning to think so. "I had wrung Impressionism dry and I finally came to the conclusion that I knew neither how to paint nor draw," the discouraged artist told a friend. "I'm sick of the so-called 'discoveries' of Impressionism."

In an effort to revitalize his work and to try a new style, with fresh subject matter, Renoir embarked on a series of voyages that lasted several years. Before he was through, he would visit Algeria, Italy, the southern coast of France, and the Channel Islands off England. (Later he would add Spain; London, England; Holland; and Germany to the list.)

The artist had never been far from home before, but listening to his rich clients talk about the foreign countries they had seen aroused his curiosity. Besides, traveling abroad was something painters had done since the Renaissance—to visit the ruins of classical antiquity, to follow in the footsteps of the old masters, and to get a fresh perspective. Renoir was convinced that the most important thing was drawing, and that he did not know how. So he proceeded to try to teach himself and, at the same time, find new inspiration from light.

Muslim Festival at Algiers. 1881
Renoir was captivated by the dazzling sunlight of Algiers after the dreary winters of Paris. The artist has chosen a high, distant viewpoint in this exotic locale, but the mass of the crowd surrounding the central dancing figures recalls one of his classic pictures of Parisian life, *Ball at the Moulin de la Galette.*

In February of 1881, he left cold and dreary Paris for the French colony of Algeria, in hot and sunny Africa. Fifty years before, the French master Delacroix had paved the way by finding exotic themes and vibrant colors there.

In Algeria, Renoir discovered white, the purest reflection of light. "Everything is white," he reported, "the burnous [hooded cloaks] they wear, the walls, the minarets [small towers], the road. And against it, the green of the orange trees and the grey of the fig trees." He tried out his newfound color in *Muslim Festival at Algiers*, which depicts a white-clad crowd watching some performers outside a mosque. Other paintings from this period, such as *Banana Plantation*, glow with tropical oranges, yellows, blues, and greens.

Not surprisingly, given the Arab sense of modesty and restrictive attitude toward women, Renoir had difficulty finding models. Most were clad from head to

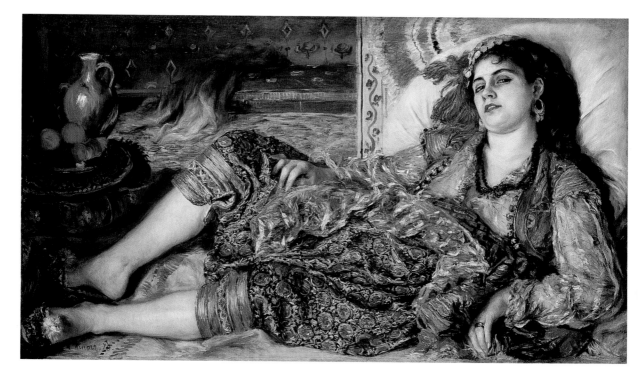

Woman of Algiers. 1870
The sensuous colors and fabrics of North Africa appealed to Renoir. Eleven years before he traveled there, he imagined this exotic harem woman, using his mistress, Lise Tréhot, as the model.

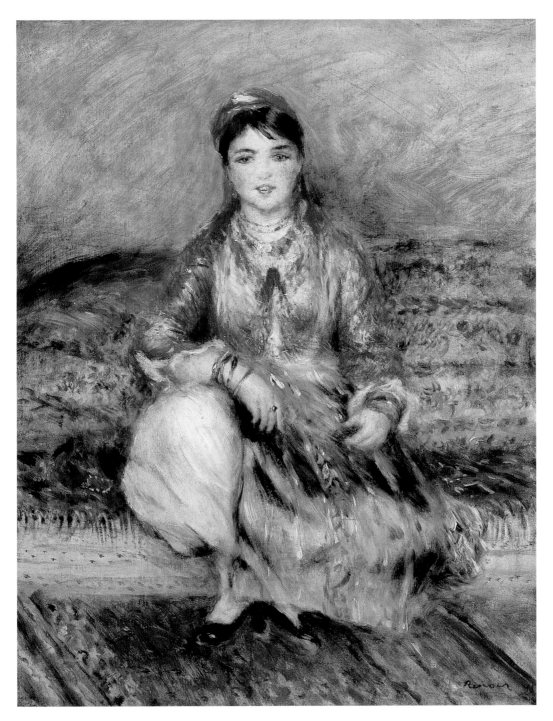

Algerian Girl. 1881

Although Renoir had trouble finding models in Algeria, where women were unaccustomed to being on their own, he did manage to get this young girl, dressed in brilliant, complementary oranges and blues, to sit for a portrait.

toe in body-concealing robes. "It's too bad," he wrote, "there are some pretty ones, but they don't want to pose."

That summer Renoir returned to Paris and Chatou, where he completed *Luncheon of the Boating Party* and some other works. He was invited to Dieppe, a port city in northern France, by Madame Emile Blanche to tutor her son, the artist Jacques-Emile Blanche. Renoir's nervous tics and uneducated ways, however, soon wore out his welcome in the sophisticated household.

In October, he took off for Italy, where he toured Venice, Rome, Naples, Calabria, Capri, and Palermo. Everywhere he went, he sketched in a little five-by-eight-inch notebook. These jottings, or thumbnail sketches, would later become the basis for paintings. Again he looked for models—even following a girl "beautiful as Madonna"—but communication got in the way. "To get someone to pose, you have to be very good friends and above all speak the language," he concluded.

Renoir enjoyed Venice, the city of canals and gondolas. Like many tourists, he sketched and painted the rose-and-white marble Doges' Palace and St. Mark's Square, with its great church, glowing soft and mysterious in the morning sun. Then, homesick, he wrote, "Ah, Paris, with its pretty women's hats, with its life, that's a sun that's possible to depict, why did I leave you?"

Renoir's greatest discovery in Venice was the work of the Renaissance artist Vittore Carpaccio, with its fresh bright colors and naïveté. "I remember especially a dragon in one of his pictures that looks as if it were a merry-go-round beast on a leash—one of those dragons you expect any moment to offer you its paw," he reportedly told his friend, the art dealer Ambroise Vollard. "And his *St. George* is baptizing the Gentiles in the midst of a gay crowd playing huge drums and trombones! Carpaccio must have gotten his models at the fairs!"

From Venice, Renoir traveled to Florence and then to Rome, where he was deeply impressed by the plaster wall paintings known as frescoes, especially those by another Renaissance artist, called Raphael. "I found the freest, the most solid, the most marvelously simple and living kind of painting that it is possible to imagine," he enthused over Raphael's work. He went to look at them several times, admiring their "simplicity and grandeur" and the way Raphael handled light.

Doges' Palace, Venice. 1881

In Venice, Renoir could not resist sketching some of the most famous landmarks. He also jotted down ideas for paintings that were finished later in his studio in Paris. Many were unimpressed with Renoir's scenic paintings of Italy, and one critic suggested that he should stick to painting people.

He was equally impressed by the frescoes at the ruins of Pompeii, the ancient city southeast of Naples that had been destroyed by the eruption of Mt. Vesuvius. Frescoes taught him the value of painting figures with just a few rich colors. When he tried to achieve the same effect in oils, however, he failed and grew disgusted. "I still have the experiment disease. I'm not pleased. I rub out, and I rub out again," he wrote to his dealer Durand-Ruel. "I'm like the children in school. The white page should always be neatly written and bang! . . . a blot. I'm still at the age

of blots . . . and I'm forty years old."

Caught up in research, Renoir tried everything from thinning his colors to painting with wax for a chalky effect. Out of it came a few pieces he liked, which he shipped to Durand-Ruel with the note, "I want to sell them to you for a very high price. These studies have cost me an arm and a leg."

On the Grand Canal, Venice. 1881

He loved the Italian countryside. In Calabria, a very poor remote area where there were few trains, bridges, or even roads, he went from port to port by fishing boat and tramped cross-country on foot. Once, when he couldn't figure how to cross a rain-swollen stream, some peasant women came to his rescue. They picked up the slender artist and his baggage and, forming a line across the water, passed him from one to the other until he was safely deposited on the other shore.

In December, Renoir found himself on the island of Capri, admiring the extraordinarily transparent blue of its grottoes and the countryside full of olive, orange, and lemon trees, and masses of wild flowers. It is very likely that he painted the luminous nude called *Blonde Bather* there, using Aline Charigot as a model. Renoir never mentioned her presence in his letters, acting as though he were traveling alone. Aline, on the other hand, referred to this trip as her "honeymoon," even though they didn't marry until nine years later.

From Capri, Renoir traveled to Palermo, to paint a quick portrait of the great German composer Richard Wagner, who was holed up trying to finish the or-

chestration for his new opera *Parsifal*. The maestro allowed him about thirty-five minutes.

Renoir returned to France early in 1882, where he joined Cézanne at L'Estaque, in the south, just west of Marseilles. Monet, Pissarro, and many other painters had also found inspiration there, drawn by the dramatic coastline, with its rugged rock formations emerging from the wild, rough sea. At L'Estaque, Renoir came down with a serious case of pneumonia and returned to Algeria to recuperate. This time he finally managed to paint some women and children, as well as a mosque, a stairway, and several other subjects.

Seven months after Renoir had left, he returned to Paris and finished the three life-size dance panels, combining Impressionistic color with the lessons he had learned while studying Italian frescoes. He created big, simple figures surrounded by air and bathed in light.

In the fall of 1883, Renoir, Aline, and a friend traveled to the English Channel Islands of Jersey and Guernsey. "What a pretty little country!" Renoir wrote of Jersey. "What pretty paths! Superb rocks, beaches such as Robinson [Crusoe] must have had on his island, besides rump-steak and ale at prices we can afford." He wrote to

By the Seashore. 1883

In this portrait of Aline, sewing on the beach on the English island of Guernsey, the artist kept her face in focus but painted the background cliffs softly to avoid distraction.

Rocky Crags at L'Estaque. 1882
Renoir painted side by side with Paul Cézanne at L'Estaque, on the Mediterranean coast just west
of Marseilles.

Durand-Ruel from Guernsey: "In spite of the small quantity of things I'll be able to bring back, I hope to give you an idea of these charming landscapes." Eighteen pictures came out of the trip, including *By the Seashore*, which shows Aline sewing by the Guernsey cliffs.

Toward the end of December, Renoir and Monet worked together again, as they had done at La Grenouillère and Argenteuil, this time along the fabled Côte d'Azur (the blue coast) of southern France, with its palm trees, sun-drenched beaches, and hillside villages with red-tiled roofs, overlooking the azure sea.

Cézanne joined them, and they all traveled together, from Marseilles to Genoa. To his dealer Renoir wrote, "We are delighted with our trip. We've seen such marvelous things, we'll probably bring back nothing or not much, because we've been mostly on the move, but what a trip! One has to stay much longer to do something. . . . We've seen everything, or just about, between Marseilles and Genoa. Everything is superb. Vistas of which you have no idea. This evening the mountains were pink."

Three years after he started, Renoir's travels came to an end, but the experiments continued. Meanwhile, the market for Renoir's paintings was drying up, an unfortunate result of the stock market crash of 1882. By 1883, the artist was poor again. Pissarro, Monet, and Sisley were also destitute. Durand-Ruel was near financial ruin.

Renoir tried to establish a new artists' group called the Société des Irrégularistes (Society of Irregularists), which amounted to a rebellion against technology and stressed the variability of natural forms—from leaves on a tree to the uneven features of the human face. Renoir published a manifesto, but nothing came of his plan, although his own work did begin to change.

In the summer of 1884, the artist visited Paul Berard, a friend and one of his major patrons, at Berard's home, Château de Wargemont, on the coast of Normandy. There he painted *The Afternoon of the Children at Wargemont*. This large and ambitious work marked a new direction for Renoir, combining realistic details, an Impressionist palette, linear forms, and a smooth paint surface. The colors were cool and dry; the light flat and even, with few shadows. It showed the influence of the great frescoes Renoir had seen in Italy. The artist's attention to drawing came from careful study of the French master Jean-Auguste-Dominique Ingres (pronounced An-gruh), who had died in 1867, and whom Renoir admired.

The painting was not well received. Many thought the figures looked like cutouts, and the colors were deemed too pale and washed-out. Several important patrons stopped collecting Renoir's work. Even his faithful dealer Durand-Ruel expressed misgivings. At the same time, Renoir pulled away from the Impressionist exhibitions, fearing that they would further damage his reputation. He was not

having much success with the Salons either—from 1884 to 1890 he submitted nothing for the juries' review.

In an 1885 letter to Berard, the artist expressed his frustration—and determination. "I'm involved in lots of things and not one of them is finished," he wrote. "I wipe out, I start over. I think the year will go by without one canvas . . . I WANT TO FIND OUT WHAT I AM LOOKING FOR BEFORE GIVING UP . . . I have gone too deeply into the series of experiments to give up without regret . . ."

The Afternoon of the Children at Wargemont. 1884
Paul Berard commissioned Renoir to paint this large (about 4 x 5') portrait of his three daughters: Marthe, fourteen; Marguerite, ten; and Lucie, four. Influenced by Italian frescoes, Renoir changed his style and began painting more simplified figures, with less vibrant colors.

Family Life

When Renoir returned to Paris in 1884, he and Aline decided to live together, much to the regret of Aline's mother, who opposed her daughter's relationship with her "penniless sweetheart." But Aline was equally strong-willed, and the couple rented a studio in the rue Saint-Georges.

Settling down made a profound difference in Renoir's life and art. Before, he had been restless, always on the move, hopping a train for England or Sicily at the drop of a hat. Now he had someone to look after him. Aline was cheerful and down-to-earth, a heavyset "country woman" from a family of winegrowers in Essoyes, who didn't put on airs. Renoir was deeply in love.

The couple moved to an apartment closer to Montmartre. There, on March 23, 1885, five years before they were married, Aline gave birth to a baby boy, whom they named Pierre. Few knew Renoir had a family. He kept his relationship with Aline a secret, perhaps embarrassed about her size and her peasant manners. Even after their marriage in 1890, he remained silent. In 1891, when he visited his upper-class artist-friend Berthe Morisot, he did not make clear his relationship to the woman or the six-year-old boy with him. Eventually Morisot figured it out. A few months later, she wrote to the poet Stéphane Mallarmé: "Renoir spent some time with us, without his wife this time. I will never be able to describe to you my amazement in the presence of this very heavy person, whom, I don't know why, I had imagined as resembling her husband's painting. I'll point her out to you this win-

Breakfast at Berneval. 1898
In the Renoirs' rented summer home at Berneval, Normandy, thirteen-year-old Pierre reads in the foreground, while Gabrielle turns to speak to Jean.

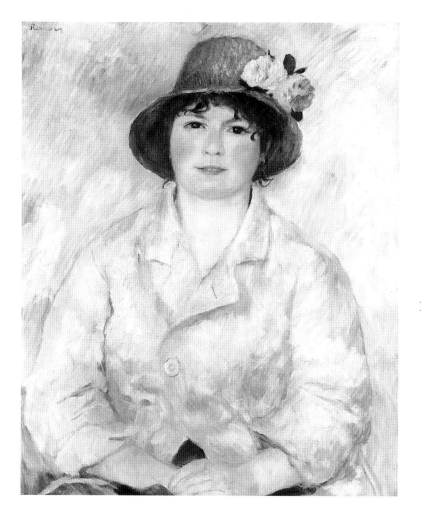

Aline. c. 1885
Renoir's beloved fiancée posed for this picture when she was twenty-six. Five years later, they married. Renoir often used Aline as a model, but here he shows her as herself, a warmhearted, simple country girl.

ter." That fall, the Renoirs visited Aline's hometown of Essoyes for the first time. They returned every summer and eventually bought a house there.

The artist's subject matter now changed, reflecting his changing life-style. Urban scenes were replaced by rural ones. Flirting couples disappeared in favor of mothers and children. He made a portrait of Aline and embarked on a series of drawings and paintings showing her nursing Pierre.

Renoir's Ingresque style continued to be rejected, and, at the age of forty-four, he felt like a failure. But he did not give up. "I know how to do only one thing, and that is to paint," he said. "I have never let a day go by without painting—or drawing, at any rate. You've got to keep your hand in." Around 1884, he began

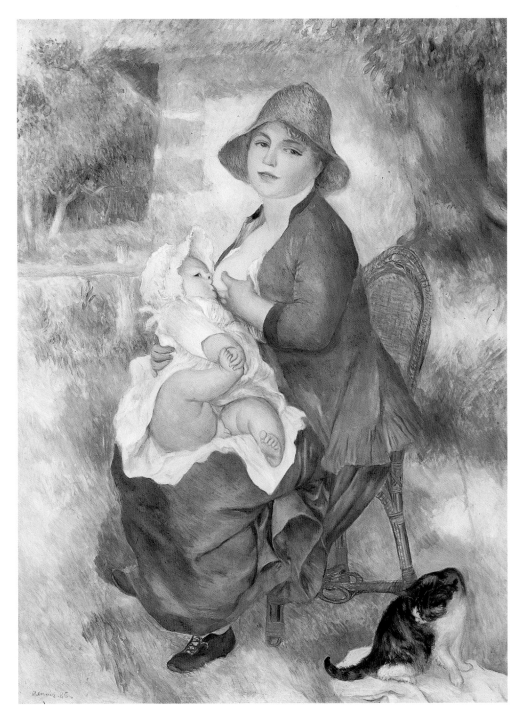

Nursing (third version). 1886
Beginning in the mid-1880s, Renoir's subject matter shifted from fashionable society to his
own family. He made several versions of this touching expression of maternal tenderness,
Aline nursing Pierre, their first-born son.

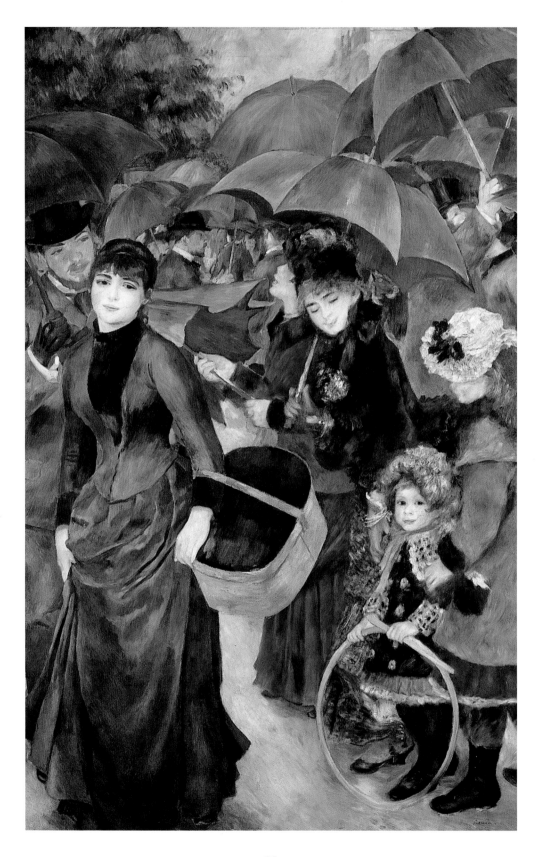

preparing for *The Bathers*, which, a few years later, would mark the culmination of his "dry" period. Meanwhile, financial good news, at least, was just around the corner.

Durand-Ruel began planning a show featuring the largest collection of Impressionist paintings ever seen together. "Works in Oil and Pastel of the Impressionists of Paris, 1886" opened in New York the following spring. On display were 310 paintings by thirty-two artists, including thirty-eight by Renoir, from the dealer's personal collection. The Americans liked what they saw. Many paintings were sold, including six by Renoir for a total of 9,000 francs, or about $1,980—not a huge sum, but encouraging.

"Do not believe that the Americans are savages," Durand-Ruel wrote to the artist Henri Fantin-Latour. "On the contrary, they are less ignorant and less conservative than our French art lovers. I have been very successful with paintings that took me twenty years to get people to appreciate in Paris." The New York show marked the turning point in public acceptance of Impressionism, and the start of improved sales. Durand-Ruel made arrangements for a second show and, in 1888, opened a gallery in New York.

Renoir was asked to paint some portraits for the second show, but when they were delivered and Durand-Ruel saw that they were in the artist's more recent "dry" style, the dealer rejected them. Renoir responded by destroying all of the paintings, scraping them down to the raw canvas. He continued his classical experiments, however, informing Berard, "I believe I'm going to beat Raphael and that people in the year 1887 are going to be amazed." Renoir was referring to *The Bathers*. It was to be a large-scale composition with several nude figures. The artist made at least twenty preparatory drawings as he carefully worked out what he

The Umbrellas. c. 1883

This picture marks a turning point in Renoir's artistic development. It can be divided into the two halves that were painted at different times. The figures on the right are shown in the soft, feathery brushwork of the artist's Impressionist period; the couple on the left and the umbrellas in the background were painted four years later in his "dry," linear style. Renoir reworked the painting many times: X rays reveal that several other arrangements of the figures lie beneath the surface.

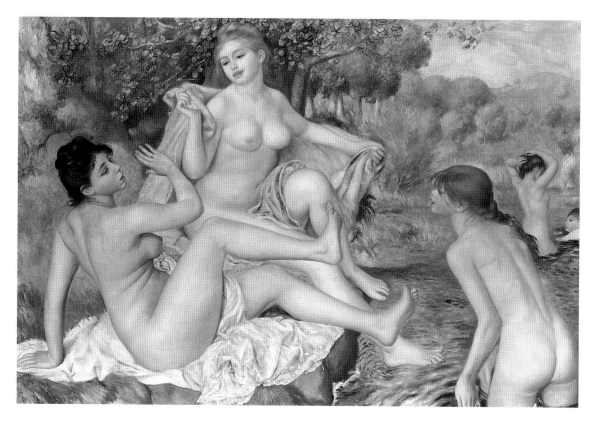

The Bathers. 1884–87

Renoir had high hopes for this large (about 4 x 5') and ambitious work. He attempted to set the linear style of the frescolike nudes against a softly focused background. No one seemed to like the effect.

wanted in the poses, trees, and drapery. With its classical theme, precise lines, and smoothly painted surface, it was the artist's ultimate homage to Ingres. In contrast, the softly painted landscape was done in his Impressionist style.

When it was finally exhibited, Renoir's most ambitious work in years not only failed to amaze but was rejected as "stiff" and "acid-colored." Devastated, the artist began to question the new direction of his painting. He ended his fresco period and returned to a more accepted style. By 1889, sales were going better for him.

In 1890, the year Renoir married Aline, the family moved to a house in Montmartre called the Château des Brouillards (Foggy Castle), an extravagant "folly" built in 1772. Perched on a hill high above Paris, the house was surrounded

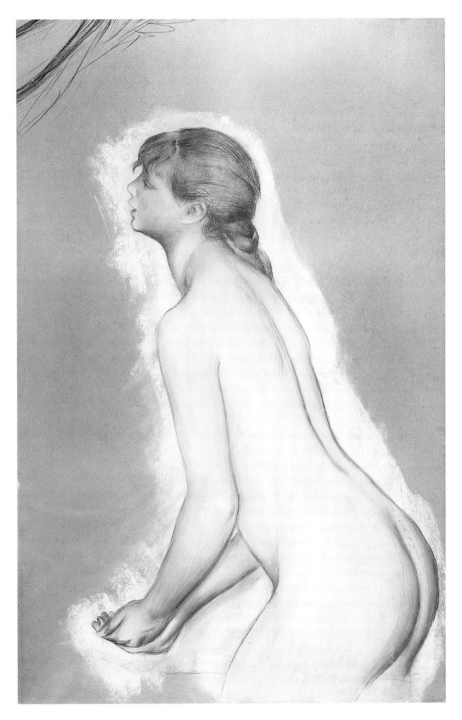

Study of Splashing Nude. c. 1884–85

Intent on improving the quality of his drawing, Renoir made many preparatory drawings for *The Bathers*. This elegant study on cardboard was drawn in pencil and chalk, touched up with a thin layer of white paint.

by rosebushes and lilacs. An orchard and a field where cows grazed extended just beyond them. The view from the attic was breathtaking. "You felt you were right up in the sky," recalled Jean, who was born there in 1894. Gabrielle Renard, Aline's fifteen-year-old cousin from Essoyes, moved in to help keep house and care for the new baby. Jean called her "Bee-bon," the closest he could come to her name.

For Renoir, it was a happy and productive time. While Aline sewed in the shade of the garden, exchanging gossip with friends, he was busy painting all day— but he kept the door open so as not to miss what was going on. Each noon he helped her prepare the meal. Frequently, she would start to sing a tune, and he would put down the beans, take out a pad, and begin to sketch her. Jean and Gabrielle often posed, as did the housekeeper and cook Marie Dupuis—called "La Boulangère" (The Bakery Girl) because she was in love with the baker's assistant. The daughters of two neighbors were the subjects for *Little Girls Playing Croquet.* Other servants and neighbors also modeled—if their skin "took the light," that is.

An 1892 letter from Aline to her husband, away on a painting trip in Normandy, demonstrates their affection for each other:

> *Tell me, my poor dear: Are you cold up there in Dieppe? We are freezing here in Paris.*
>
> *Are you working hard? Will your portraits be finished soon? Our trip this winter seemed much shorter than the past two weeks without you.*
>
> *Write to me often, and tell me if you are well.*
> *All my love,*
> *Aline*

Renoir was a proud—if nervous—father, with definite—sometimes odd— theories about raising children. He believed that young eyes should be exposed only to pretty colors, flowers, and simple, handmade objects. He was opposed to strict training and thought that children should be allowed to explore the world on their own. They didn't require schooling until age ten; they would catch up quickly enough.

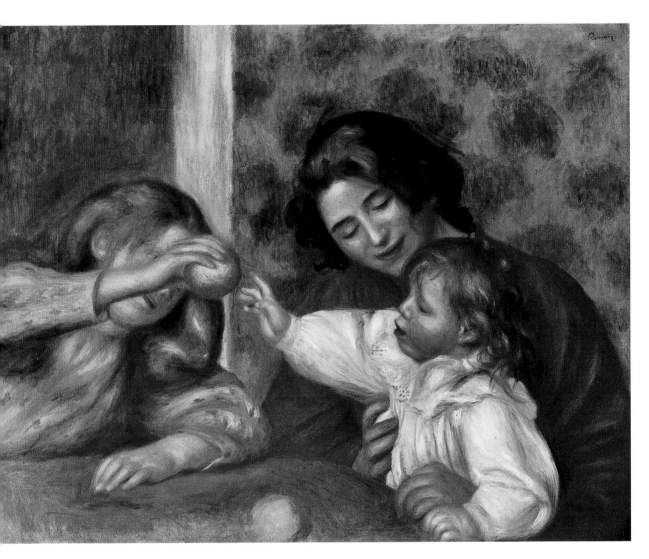

Gabrielle and Jean and a Little Girl. c. 1895

Aline's fifteen-year-old cousin, Gabrielle, was hired as Jean's nursemaid. Over the next twenty years, she frequently posed for Renoir.

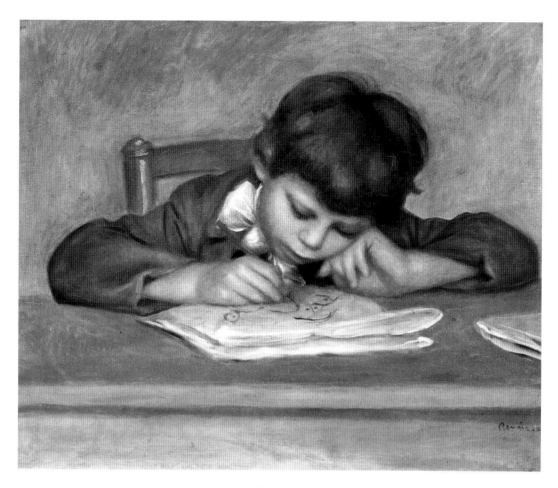

Jean Drawing. 1901
Renoir was a devoted father and made many paintings of his children. Jean, shown here at age
seven, grew up to be a famous filmmaker in Paris.

Always worried about safety, he made sure the house was cleared of any
sharp edges, even going so far as to round off the corners of marble mantelpieces
and to sand down the edges of tables. As long as there were children growing up in
the Renoir household, the floors were not to be waxed, and the lower panes in glass
doors would remain boarded up. Of course, no child was allowed to handle knives,
needles, or matches.

He kept their hair long, to protect them if they fell down, and even selected
their toothbrushes, picking ones with soft bristles so as not to harm the enamel on

their small teeth. To strengthen their manners, he taught them to do without the finer things in life and to eat what was served whether they liked it or not. Finally, they were brought up to treat everyone alike—Christian and Jew, black and white—lest they develop a "wrong scale of values," his son Jean recalled.

The children always came first. Once, while he was away painting in Marseilles, Renoir got a telegram saying that Jean, who was less than a year old, had come down with pneumonia—a potentially fatal disease in those days. "He left his canvas and brushes, hurried to the station without even taking his suitcase, and jumped into the first train for Paris," Jean later related.

Several years later, when Jean was sent for the first time alone to fetch a pack of cigarettes for his father from the local tobacco shop, Renoir panicked when the boy was a few minutes late. "It's not only that the traffic might run you over," he teased, relieved to find Jean safe and sound, "but kidnappers might steal you. Or the Salvation Army might get you and make you sing with an English accent."

The children were favorite subjects for paintings. When they were young, he waited until they found something that interested them, rather than force them into a pose. In this way, Jean recounted, Renoir created *Jean with Building Blocks*, *Jean Playing with Toy Soldiers*, *Jean Looking at a Picture-Book*, *Jean Drawing*, and *Jean Eating Soup.* All Renoir asked was that his model remain more or less quiet in front of some fabric pinned to the wall. Sometimes they had to hold still for a minute, while he focused on some detail. After he finished, they could relax again and go back to what they had been doing. If Jean became restless, Gabrielle would read fairy tales to him. If he still would not settle down, his father dismissed him and turned to other canvases in progress.

Renoir's success picked up markedly after 1890. Americans were buying his work. Durand-Ruel purchased seventeen of his paintings that year. Renoir even risked submitting to the Salon, which accepted his painting of three girls at a piano but hung it under an awning where it could barely be seen. It was the last time Renoir bothered to submit anything. He didn't need to: he was making money now.

The family continued to spend summers in Essoyes, and in 1898 they bought their own house in the village. Their third son, Claude (nicknamed Coco) was born

there in 1901. Essoyes was a magical place to grow up. The slopes were covered with grapevines and trees. At the bottom of the valley flowed the Ource River, a tributary of the Seine that Renoir liked to paint.

The village was picturesque. The thick-walled houses were made of flat stones that blocked the hot summer sun so effectively, Jean recalled, that they wore coats indoors to ward off the chill. There were also big cool barns containing huge vats of fermenting grapes. Life, however, centered around the large open fireplaces in the kitchens, where there was always a pot of stew or soup simmering. Renoir particularly enjoyed the big round loaves of homemade bread and the fragrant plum, grape, and apple tarts. While Pierre and Jean joined the local boys and girls, exploring the banks of the river and playing in the woods, Aline invited many of her husband's friends to visit, so he would not miss the social life of Paris.

The days passed, happy and peaceful. Jean remembered how he would be awakened early in the morning by Gabrielle, moving about in the room next door that she shared with a model from Paris. Jean would get dressed and greet his father, already up and sitting in the dining room alone. Renoir would have a cup of coffee with hot milk and a slice of brown bread toasted in the fireplace and buttered.

After Renoir had his first cigarette, the frequent houseguests would join him around the table. Then, as the artist set out to paint, some would go fishing, while others settled down to read. Aline bathed and nursed Coco, then oversaw the large, bustling household. "I have the feeling she was completely happy," wrote Jean. In the evenings, they all gathered around the piano for a concert or played guessing games.

Among Jean's fondest memories of the summers there: "The quiet pleasure of being with Renoir as he painted in a meadow on the side of the river near the older paper-mill; my mother's red dressing-gown as she sat in the tall grass; the children's voices as they ran after one another around the willow trees." Departure in the fall was always a sad time.

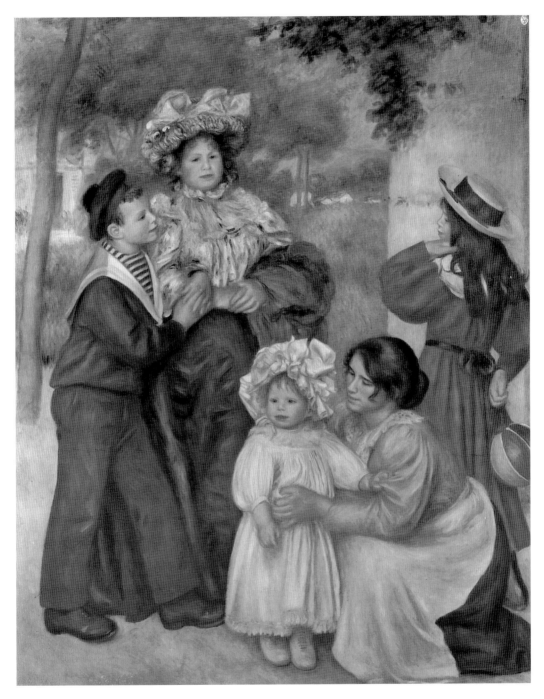

The Artist's Family. 1896

Renoir painted his family in the garden of their house in Montmartre. Aline stands arm in arm with Pierre, in a sailor suit, who would become an actor. Cousin Gabrielle kneels with Jean, who, like all little boys at the time, wears a dress. On the right is a young neighbor. Claude had not yet been born.

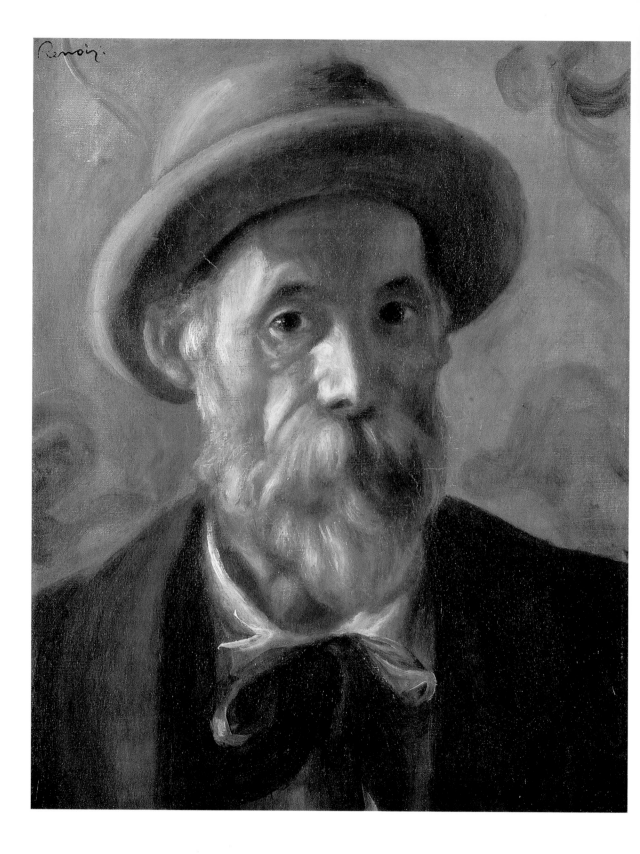

The Final Years

Renoir came down with his first attack of rheumatoid arthritis in December of 1888. It began with facial paralysis and trouble with his teeth, eyes, and ears. Two months later he recovered. In September 1897, Renoir was riding his bicycle in Essoyes on a rainy day when he lost control in a puddle and fell, breaking his right arm, the same arm he had fractured in 1880. A doctor set the bone, applied a plaster cast, and that was the end of it. Or so the artist thought—being ambidextrous, he was able to paint with his left hand while the right one healed.

That winter, however, he felt a slight twinge in his right shoulder and noticed that his hands were getting stiff. To keep them flexible, Renoir took up juggling and felt better for a while. Then, in 1898, he suffered a terrible attack of pain in his right arm and couldn't paint at all for several days. That really scared him. For Renoir, not being able to paint was to give up on life.

He was fifty-seven, but felt prematurely old and walked with a cane. A self-portrait painted in 1899 reveals the artist as haggard and gray. "At first he made himself a little too stern and wrinkled," noted sixteen-year-old houseguest Julie Manet of the work. Julie's mother, the Impressionist Berthe Morisot, had died of pneumonia in 1894, at the age of fifty-four. Her father Eugène, whose brother was Edouard Manet, had passed away three years earlier. Renoir looked after the orphan, inviting her to visit many times. "We absolutely insisted that he remove a few wrinkles and now it's more like him," Julie wrote of the self-portrait. Still,

Self-Portrait. 1899
Only fifty-eight years old, but suffering from rheumatoid arthritis, Renoir looked like an old man.

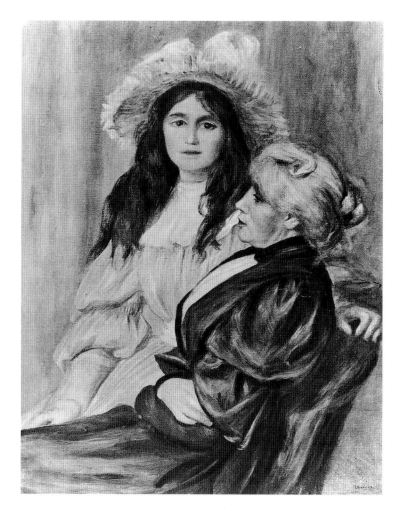

Berthe Morisot and Her Daughter, Julie. 1894

she observed in her diary, "It is so painful to see him in the morning not having the strength to turn a doorknob."

Renoir's paintings were now fetching more than those of the other Impressionists. In 1900, the French government honored him for service to the state and named him a *chevalier* (knight) of the Legion of Honor, a distinction that made Monet jealous and caused a temporary falling out between the two friends.

Although he was partially disabled, Renoir continued to paint. He had finally found a way to combine the light and colors of Impressionism with the more solid-looking figures of his Ingresque period. He turned out a tremendous number of canvases in these years, with a wide variety of subjects: children, mothers, nudes, landscapes, portraits, and still lifes. Young Coco became a favorite model. Collectors and dealers were clamoring for Renoir's paintings, and his work appeared in several important shows.

Arthritis attacks were followed by remissions when he could paint without pain. Each episode, however, left the artist a little weaker, his knuckles more stiff

and swollen, the fingers more twisted. He sought a cure at health spas, where soaking in mineral waters was thought to provide relief.

Renoir confided to Durand-Ruel, "What bothers me most at this moment is not being able to remain seated because I'm so skinny: ninety-seven pounds. That's not fat. The bones go through the skin and after awhile I can't bear to sit . . . I really think things are all botched up for painting. I won't be able to do anything any more. You must understand that under the circumstances, nothing interests me." Despite the artist's bouts of poor health and understandable depression, the most vibrant colors of his career now dominated his palette, which had expanded to include four different reds. Renoir's international reputation was growing. In 1907, *Madame Charpentier and Her Children* was sold to the Metropolitan Museum of Art in New York City for 84,000 francs (the equivalent of $63,000).

Another, less positive, sign of his growing popularity was the increased number of forgeries and forged signatures. Durand-Ruel shipped some of the artist's paintings back to him for authentication. Renoir grew tired of it, telling his dealer, "There was no need to examine them carefully, it is ridiculously stupid. The woman reading, false even to the signature. The woman full face, much touched up, the costume finished and the signature false, but so blatantly false."

For a number of years the Renoirs had been renting villas at Cagnes-sur-Mer, a charming village in the south of France where the warm dry climate helped ease his aches and pains. In 1908, the artist built his own villa there, Les Collettes, on some five acres of land, with large groves of olive and orange trees and a beautiful view of the Mediterranean Sea. Monet was one of the first visitors. He was in excellent health at age sixty-eight. The same, however, could not be said of his colleagues. Sisley had died in 1899; Pissarro in 1903. Cézanne passed away in 1906. Bad tempered to the end, he had written, "I despise all living painters, except Monet and Renoir."

Renoir would spend the last twelve years of his life at Les Collettes, which is now preserved as a museum. There were three studios on the property, including one with large glass windows set among the trees, so Renoir could enjoy painting the outdoors while being protected from the weather. No longer able to walk, he

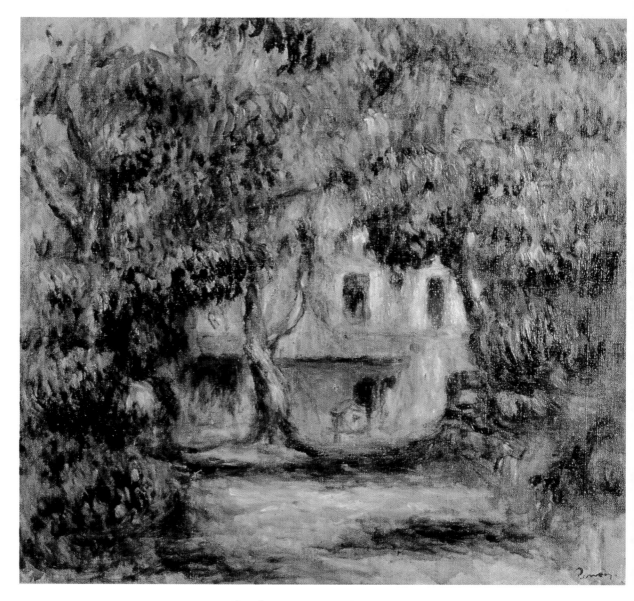

The Farm at Les Collettes. c. 1915
There was an old farmhouse on the property that Renoir bought in Cagnes-sur-Mer. Eventually he
built a large house and several studios there.

Renoir's studio, Les Collettes
Under the olive trees, a studio with large windows was constructed to protect Renoir from the weather, while still giving him the sense of painting outdoors.

was carried around the grounds in a sedan chair, a portable chair supported by two bamboo poles. Or he was lifted out of his bed into a wheelchair and pushed around the garden.

"What struck outsiders coming into his presence for the first time were his eyes and hands," recalled Jean Renoir about his father at age seventy. "His eyes were light brown, verging on yellow. His eyesight was very keen. Often he would point out to us on the horizon a bird of prey flying over the valley of the Cagnes, or a ladybug climbing up a blade of grass lost among other blades of grass . . . So much for the physical aspect of his eyes. As for their expression, imagine a mixture of irony and tenderness, of joking and sensuality. They always looked as though they were laughing . . . but this laugh was a tender laugh, a loving laugh.

"Perhaps it was also a mask. For Renoir was extremely modest and did not like to reveal the emotion that overwhelmed him while he was looking at flowers, women, or clouds in the sky . . ."

By now, Renoir's hands were as twisted as his beloved olive trees. Rheumatism had racked the joints, bending the thumb toward the palm and the other fingers toward the wrist. "Visitors who weren't used to it couldn't take their eyes off this mutilation," Jean said. "Their reaction, which they didn't dare express, was: 'It's not possible. With those hands, he can't paint these pictures. There's a mystery!' The mystery was Renoir himself."

In order for Renoir to paint, a piece of cloth had first to be inserted into the hollow of his clawlike hand, and then a brush. Large canvases mounted on two cylinders—one near the ground, the other seven feet above—were cranked to roll the painting either up or down, bringing the section Renoir wanted to work on within reach of his arm and eye. Renoir managed to move the brush from the canvas to the turpentine, then back to the palette again for more paint. At the end of each session, the brush was slowly removed from his paralyzed fingers, which could no longer open themselves. And so, Renoir adapted to his disability and kept on painting.

What paintings they were! The monumental figures glowed with color. There was an affectionate portrait of Aline with her little dog Bob. She rarely posed for her husband anymore. A portrait of Durand-Ruel conveys the dealer's gentle temperament. Most notable were the nudes, which Renoir painted in abundance now, perhaps to forget his suffering, pouring all of the joyous celebration of life into his work. In stark contrast, photographs of the artist reveal the toll his illness was taking. Self-portraits candidly portray his fixed stare, caused by a damaged optic nerve, that so unsettled people meeting him for the first time.

Renoir wrote to his longtime friend Georges Rivière, "In the battle I have *lost my legs*. I am *unable to get up*, sit down, or take a step without being helped. Is it forever??! That's it. I sleep badly, tired out by my bones, which tire the skin."

After a visit, Durand-Ruel reported, "Renoir is in the same sad condition

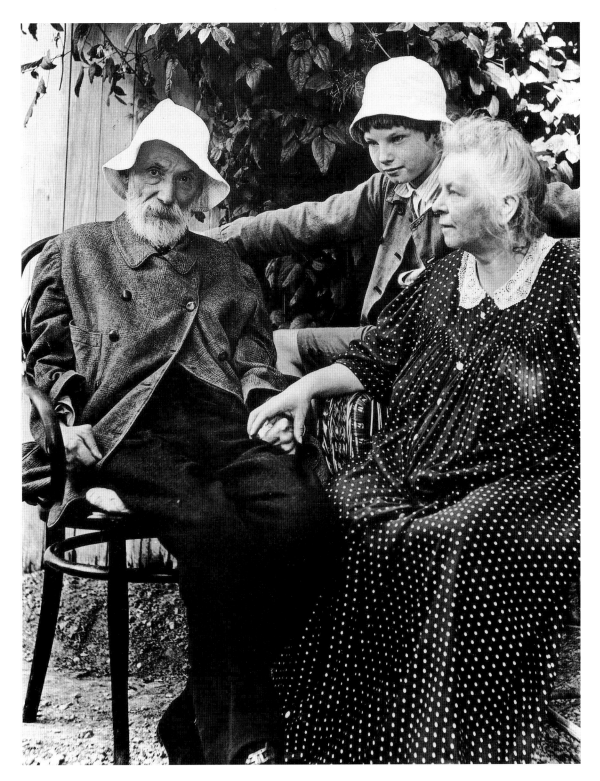

Renoir with Aline and Coco, c. 1912

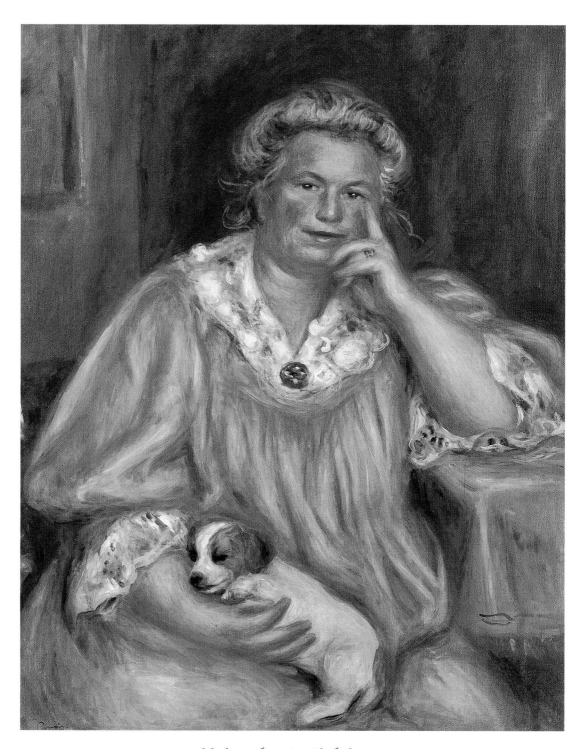

Madame Renoir with Bob. 1910
At fifty, Aline was quite heavy, had diabetes, and looked older than her years. Renoir, however,
captured her kind, maternal spirit.

but still amazing for his strength of character. He is unable to walk or even to get up from his armchair. He has to be carried everywhere by two people. What torture! And still the same good humor, the same happiness when he can paint . . ."

At this point Renoir's popularity was assured. In 1912, more than 260 of his paintings were displayed in eleven one-man shows and group exhibitions in cities from Paris to New York. Critics and reviewers raved about them. Of a retrospective show in Paris, where fifty-two of the artist's paintings were on display, art historian and collector Achille Segard wrote, "Renoir occupies a place in contemporary art completely apart. He is a discoverer. He owes nothing except to himself and to his genius. He is inimitable. One can perhaps imagine painters who could imitate Claude Monet. Woe to those who try to imitate Renoir. He

Renoir, 1916
Although he was in constant pain near the end of his life, Renoir never stopped painting.

is a force of nature . . ." After all the years of critical rejection, such praise must have seemed bittersweet.

In a brief return to ceramics, Renoir made some oil studies for pottery decorations. He had a kiln, an oven used for drying clay, built in his garden and began designing and decorating plates. He taught the skill to his fourteen-year-old son Coco, who later became a famous ceramist. In this way Renoir carried on the legacy of his hometown, Limoges, just as his father had intended.

By now Renoir was selling everything he painted, but, even with financial success, personal peace eluded him. Aline had been ill for some time with diabetes, a blood sugar disease that left her very tired. The remedy, insulin, had not yet been discovered. In 1915, as World War I raged across Europe, Jean was struck in the thigh by a German bullet during battle. Shortly after visiting him in the infirmary, Aline died of a heart attack. She was fifty-six.

Devastated by the loss of his beloved companion of thirty-six years, Renoir buried Aline at Essoyes, marking her grave with a bronze bust designed from the

Oil studies for pottery decorations. c. 1913–15
Late in life, Renoir came full circle to the days in his youth when he had painted pottery at a
porcelain factory.

portrait he had made of her in 1885. He would have to face the pain—and fame—of his final years alone.

In 1917, *Umbrellas* (see page 66), painted in 1883, was given to the National Gallery in London. A hundred English artists and collectors signed a letter praising Renoir: "From the moment your picture was hung among the famous works of the old masters, we had the joy of recognizing that one of our contemporaries had taken at once his place among the great masters of the European tradition." That August, Ambroise Vollard visited Renoir in Essoyes and posed in a bullfighter's suit he had bought in Barcelona. In 1918, Renoir painted *The Great Bathers*, his last masterwork, a vision of two voluptuous young women reclining in a landscape.

In 1919, his last year of life, Renoir painted *Girl with a Mandolin* and *The Concert*—bold compositions, with vibrant golds and reds. By then he was skeletal, his voice so weak he could barely be heard. But he continued to paint every day until his death.

On December 3, 1919, at the age of seventy-eight and ill with pneumonia, Renoir's heart failed. According to his son Jean, he had asked for his brushes and palette just a few hours earlier, wanting to paint some flowers. As he handed them back to his nurse, he murmured, "I think I'm beginning to understand something about this." He is buried at Essoyes, next to Aline.

A few months before his death, Renoir learned that a portrait he had painted in 1876–77 of the same woman who had appeared in *Madame Charpentier and Her Children*, had been bought for the Louvre—by now the national art museum of France. He wanted to see it again, and so a special visit was arranged. The disabled artist was carried slowly through the galleries in his sedan chair, accompanied by museum curators and a friend.

What went through his mind as he gazed at the picture that he had painted years back is left for us to wonder. Was he reminded of the Salon exhibitions and the skimpy meals? How far he had come from rejection and poverty! Did he still see encouragement in the face of Marguerite Charpentier, his long-dead patron and friend?

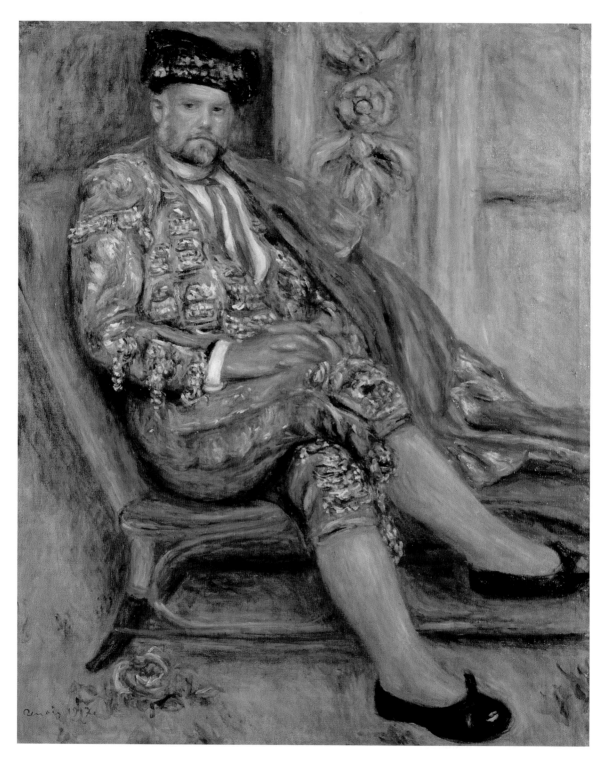

Ambroise Vollard Dressed as a Toreador. 1917

Perhaps, as he gazed up at the portrait, Renoir heard the distant echo of carefree little boys playing cops and robbers in the courtyard, when the Louvre was still a palace, so many years ago. Now that little boy, from a poor home, had grown up to see his art hanging among that of the greatest painters in the world.

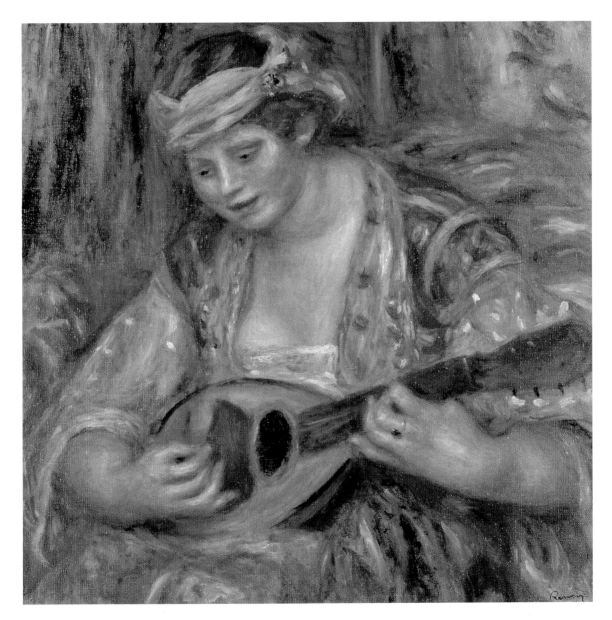

Girl with a Mandolin. 1919
Just months before he died, Renoir made some of the most luminous paintings of his career.

List of Illustrations

Page 1: *Enfant au Polichinelle*. c. 1874–75. Oil on canvas, 21⅞ x 18". Private collection. Photograph © Christie's Images, New York

Page 2 (detail): *Luncheon of the Boating Party*. 1881. Oil on canvas, 51 x 68". The Phillips Collection, Washington, D.C.

Pages 4–5 (detail): *La Grenouillère*. 1869. Oil on canvas, 26 x 31⅞". Nationalmuseum. The Swedish National Museums, Stockholm

Page 6: *Self-Portrait*. 1876. Oil on canvas, 27⅞ x 21½". Courtesy of the Fogg Art Museum. Harvard University Art Museums. Cambridge, Massachusetts. Bequest from the Collection of Maurice Wertheim, Class of 1906. Photograph © President and Fellows, Harvard College, Harvard University Art Museums

Page 9: Etienne Bouhot. *Entrance to the Louvre Museum*. 1822. Oil on canvas. Musée Carnavalet, Paris

Page 10: Vase, painted by Renoir. 1857. Oil on bronze-mounted porcelain, height 11¾". Musée des Arts Décoratifs, Paris

Page 14: Frédéric Bazille. *Pierre-Auguste Renoir*. 1867. Oil on canvas, 24½ x 20". Musée d'Orsay, Paris. Photograph © Réunion des Musées Nationaux, Paris

Page 15: *Frédéric Bazille at His Easel*. 1867. Oil on canvas, 41⅞ x 29¼". Musée d'Orsay, Paris. Photograph © Réunion des Musées Nationaux, Paris

Page 17: *Spring Bouquet*. 1866. Oil on canvas, 41¼ x 31⅝". Courtesy of the Fogg Art Museum. Harvard University Art Museums, Cambridge, Massachusetts. Bequest of Grenville L. Winthrop. Photograph © President and Fellows, Harvard College, Harvard University Art Museums

Page 18: *William Sisley*. 1864. Oil on canvas, 32⅛ x 25¾". Musée d'Orsay, Paris. Photograph © Réunion des Musées Nationaux, Paris

Page 20: Edouard Manet. *Le Déjeuner sur l'herbe*. 1863. Oil on canvas, 84¼ x 106¼". Musée d'Orsay, Paris. Photograph © Réunion des Musées Nationaux, Paris

Page 22 (left): *Lise with a Parasol*. 1867. Oil on canvas, 71½ x 44½". Museum Folkwang Essen, Germany

Page 22 (right): Caricature of *Lise with a Parasol* by Gill in *Le Salon pour rire*. 1868. Engraving. Bibliothèque Nationale de France, Paris

Page 23: The Salon of 1868, after drawing by Gustave Doré. Photograph: Collection Roger-Viollet, Paris

Page 25 (above): Claude Monet. *La Grenouillère*. 1869. Oil on canvas, 29⅜ x 39¼". The Metropolitan Museum of Art, New York. H. O. Havemeyer Collection. Bequest of Mrs. H. O. Havemeyer, 1929 (20.100.112). Photograph © 1974 by The Metropolitan Museum of Art

Page 25 (below): *La Grenouillère*. 1869. Oil on canvas, 26 x 31⅞". Nationalmuseum. The Swedish National Museums, Stockholm

Page 27: *The Gust of Wind*. c. 1872. Oil on canvas, 20½ x 32½". Fitzwilliam Museum. University of Cambridge, Cambridge, England

Page 28: *Madame Monet Reading "Le Figaro."* 1872. Oil on canvas, 21 x 28¼". Calouste Gulbenkian Foundation, Lisbon, Portugal

Page 31: *A Morning Ride in the Bois de Boulogne*. 1873. Oil on canvas, 102¾ x 89". Hamburger Kunsthalle, Hamburg, Germany. Photograph: Elke Walford, Hamburg

Page 32: *La Loge*. 1874. Oil on canvas, 31½ x 25". Courtauld Gallery, London

Page 34: Color wheel from Michel-Eugène Chevreul's *On Colors and Their Applications to the Industrial Arts*, Paris, Baillère, 1864. Private collection

Page 35: *Nude in the Sunlight*. 1875–76. Oil on canvas, 31¼ x 25". Musée d'Orsay, Paris. Photograph © Réunion des Musées Nationaux, Paris

Page 36: *Country Dance*. 1883. Oil on canvas, 71 x 35½". Musée d'Orsay, Paris. Photograph © Réunion des Musées Nationaux, Paris

Pages 37–38: *Ball at the Moulin de la Galette*. 1876. Oil on canvas, 51½ x 69". Musée d'Orsay, Paris. Photograph © Réunion des Musées Nationaux, Paris

Pages 39–40: *Luncheon of the Boating Party*. 1881. Oil on canvas, 51 x 68". The Phillips Collection, Washington, D.C.

Page 41: *City Dance*. 1883. Oil on canvas, 71 x 35½". Musée d'Orsay, Paris. Photograph © Réunion des Musées Nationaux, Paris

Page 42: *Dance at Bougival*. 1883. Oil on canvas, 71⅝ x 38⅝". Courtesy, Museum of Fine Arts, Boston. Picture Fund

Page 45: Photograph of the Moulin de la Galette. Photograph: Collection Roger-Viollet, Paris

Pages 46–47: *Madame Charpentier and Her Children.* 1878. Oil on canvas, 60½ x 74⅞". The Metropolitan Museum of Art, New York. Catharine Lorillard Wolfe Collection. Wolfe Fund, 1907 (29.100.125). Photograph © 1979 by The Metropolitan Museum of Art

Page 50: *Muslim Festival at Algiers.* 1881. Oil on canvas, 28¾ x 36⅝". Musée d'Orsay, Paris. Photograph © Réunion des Musées Nationaux, Paris

Page 52: *Woman of Algiers.* 1870. Oil on canvas, 27¼ x 48¼". National Gallery of Art, Washington, D.C. Chester Dale Collection. Photograph © 1997 Board of Trustees, National Gallery of Art

Page 53: *Algerian Girl.* 1881. Oil on canvas, 20 x 16". Courtesy, Museum of Fine Arts, Boston. Juliana Cheney Edwards Collection

Page 55: *Doges' Palace, Venice.* 1881. Oil on canvas, 21½ x 26". Sterling and Francine Clark Art Institute, Williamstown, Massachusetts. Photograph © Sterling and Francine Clark Art Institute

Page 56: *On the Grand Canal, Venice.* 1881. Oil on canvas, 21¼ x 25⅝". Courtesy, Museum of Fine Arts, Boston. Bequest of Alexander Cochrane

Page 57: *By the Seashore.* 1883. Oil on canvas, 36¼ x 28½". The Metropolitan Museum of Art, New York. H. O. Havemeyer Collection. Bequest of Mrs. H. O. Havemeyer, 1929 (29.100.125). Photograph © 1979 by The Metropolitan Museum of Art

Page 58: *Rocky Crags at L'Estaque.* 1882. Oil on canvas, 26⅛ x 31⅞". Courtesy, Museum of Fine Arts, Boston. Juliana Cheney Edwards Collection.

Pages 60–61: *The Afternoon of the Children at Wargemont.* 1884. Oil on canvas, 50 x 68¼". Staatliche Museen zu Berlin. Preussischer Kulturbesitz. Nationalgalerie. Photograph: Bildarchiv Preussischer Kulturbesitz, Berlin

Page 62: *Breakfast at Berneval.* 1898. Oil on canvas, 31⅞ x 25⅝". Private collection

Page 64: *Aline.* c. 1885. Oil on canvas, 25¾ x 21¼". Philadelphia Museum of Art. W. P. Wilstach Collection

Page 65: *Nursing* (third version). 1886. Oil on canvas, 29 x 21¼". Private collection

Page 66: *The Umbrellas.* c. 1883. Oil on canvas, 71 x 45". The National Gallery, London

Page 68: *The Bathers.* 1884–87. Oil on canvas, 46⅜ x 67¼". Philadelphia Museum of Art. The Mr. and Mrs. Carroll S. Tyson Jr. Collection

Page 69: *Study of Splashing Nude.* c. 1884–85. Red and white and black chalk, with brush and red and white chalk wash, on cardboard, 38¾ x 25¼". The Art Institute of Chicago. Bequest Kate L. Brewster, 1949.514. Photograph © 1998 The Art Institute of Chicago

Page 71: *Gabrielle and Jean and a Little Girl.* c. 1895. Oil on canvas, 25⅜ x 31½". Private collection

Page 72: *Jean Drawing (Jean Renoir Dessinant).* 1901. Oil on canvas, 17¾ x 21½". Virginia Museum of Fine Arts, Richmond, Virginia. Collection of Mr. and Mrs. Paul Mellon. Photograph © 1998 Virginia Museum of Fine Arts

Page 75: *The Artist's Family.* 1896. Oil on canvas, 68 x 54". The Barnes Foundation, Merion, Pennsylvania

Page 76: *Self-Portrait.* 1899. Oil on canvas, 16¼ x 13¼". Sterling and Francine Clark Art Institute, Williamstown, Massachusetts. Photograph © Sterling and Francine Clark Art Institute

Page 78: *Berthe Morisot and Her Daughter, Julie.* 1894. Oil on canvas, 32 x 25¾". Private collection

Page 80: *The Farm at Les Collettes.* c. 1915. Oil on canvas, 18 x 20". Ville de Cagnes-sur-Mer. Musée Renoir, France

Page 81: Photograph of Renoir's studio at Les Collettes, Cagnes-sur-Mer. Photograph: Droits Réservé. Document Archives Durand-Ruel, Paris

Page 83: Photograph of Renoir with Aline and Coco. c. 1912. Photograph: Barbara Ehrlich White, *Renoir: His Life, Art, and Letters*, Harry N. Abrams, Inc., New York, © 1984

Page 84: *Madame Renoir with Bob.* 1910. Oil on canvas, 32 x 25⅝". The Wadsworth Atheneum, Hartford, Connecticut. The Ella Gallup Sumner and Mary Catlin Sumner Collection Fund

Page 85: Photograph of Renoir painting under an umbrella. 1916. Photograph: Droits Réservé. Document Archives Durand-Ruel, Paris

Page 86: Oil studies for pottery decorations. c. 1913–15. 7 x 12½". Private collection

Page 88: *Ambroise Vollard Dressed as a Toreador.* 1917. Oil on canvas, 40¼ x 32¾". Collection Nippon Television Corporation, Tokyo

Page 89: *Girl with a Mandolin.* 1919. Oil on canvas, 22 x 22". Private collection

Index